Tree Theme Adult Coloring Book

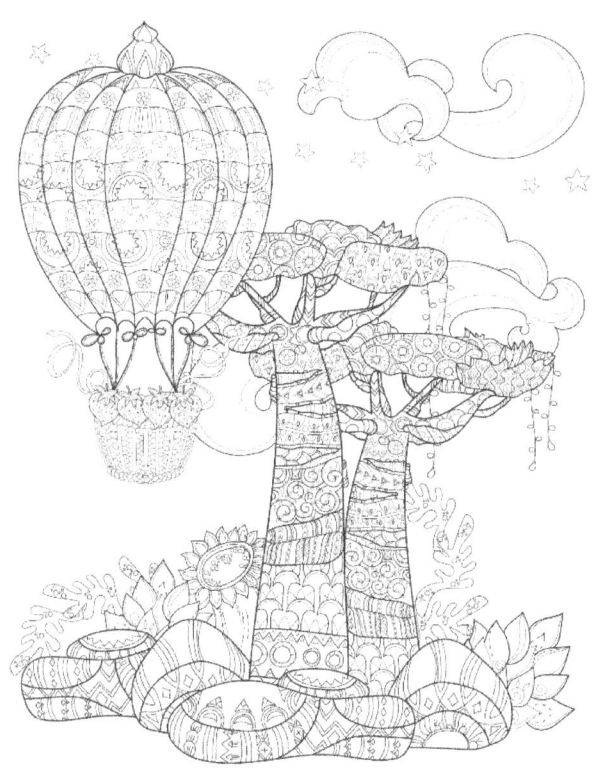

Gail Kamer

All rights reserved.

Illustration credit for front cover and above: Bigstockphoto.com: YAZZIK- 130944833

Illustration credit: Bigstockphoto.com: Katerinad_Dav- 102398852

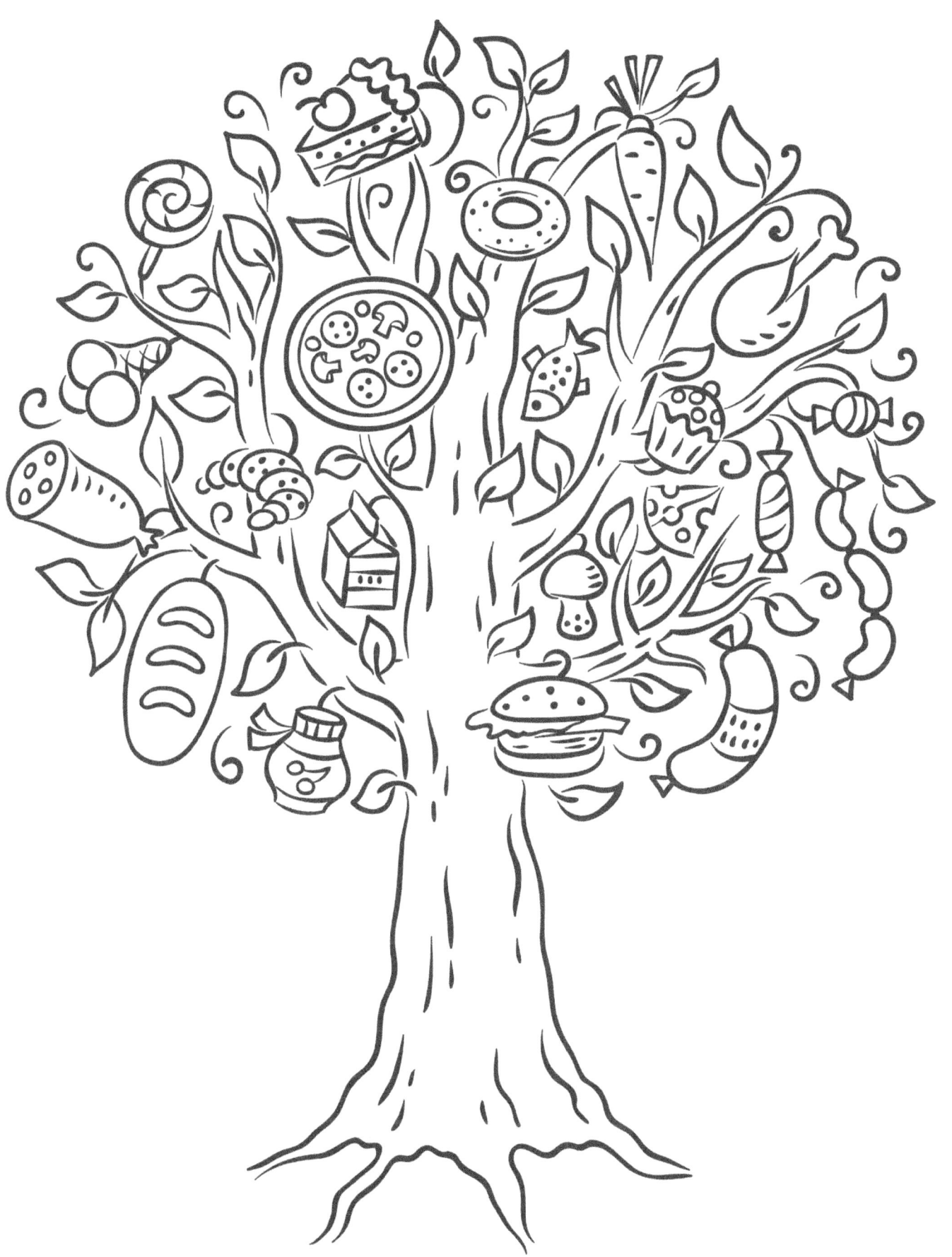

Illustration credit: Bigstockphoto.com: YAZZIK- 132389519

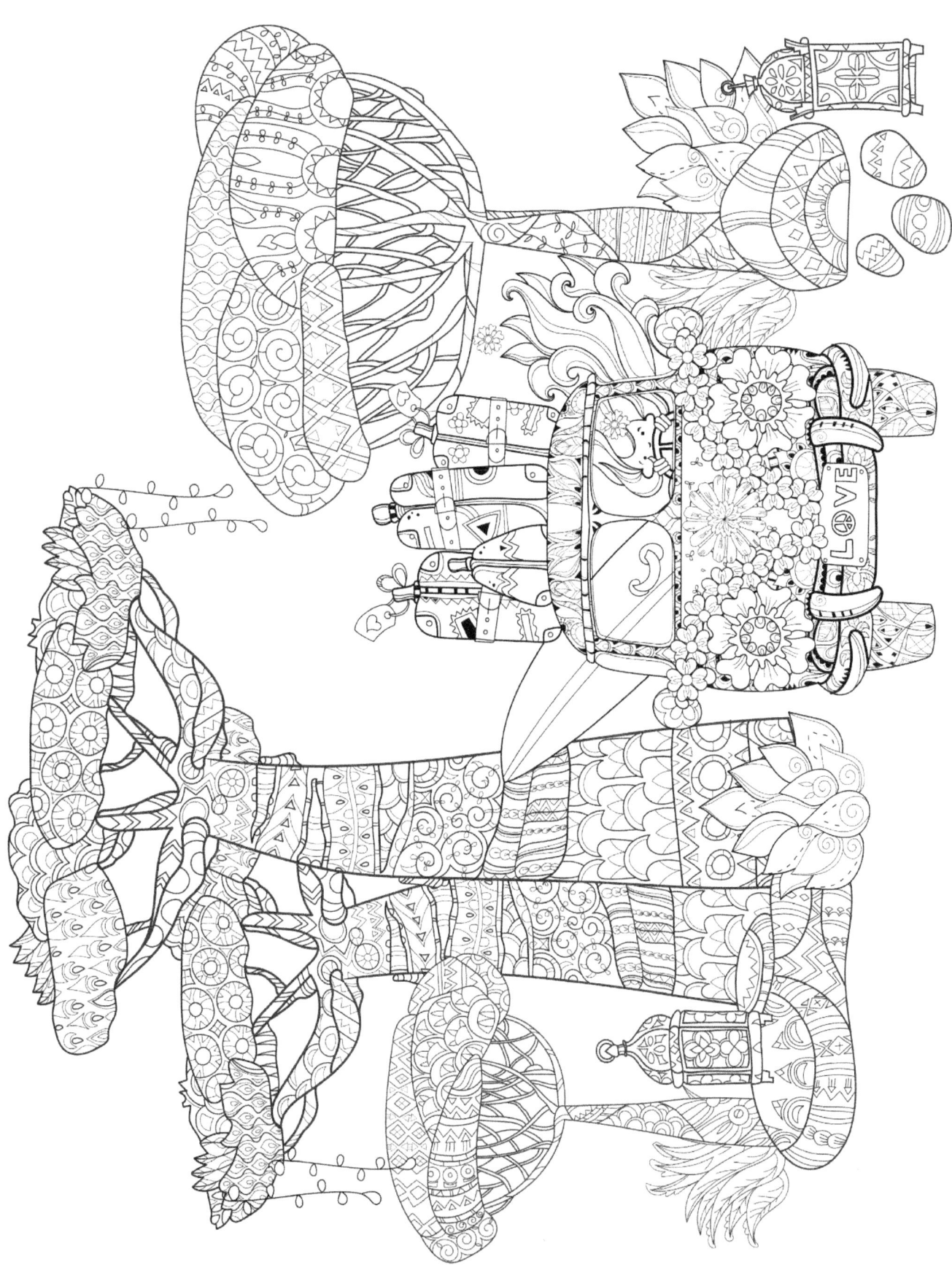

Illustration credit: Bigstockphoto.com: Martina Dedic-133911215

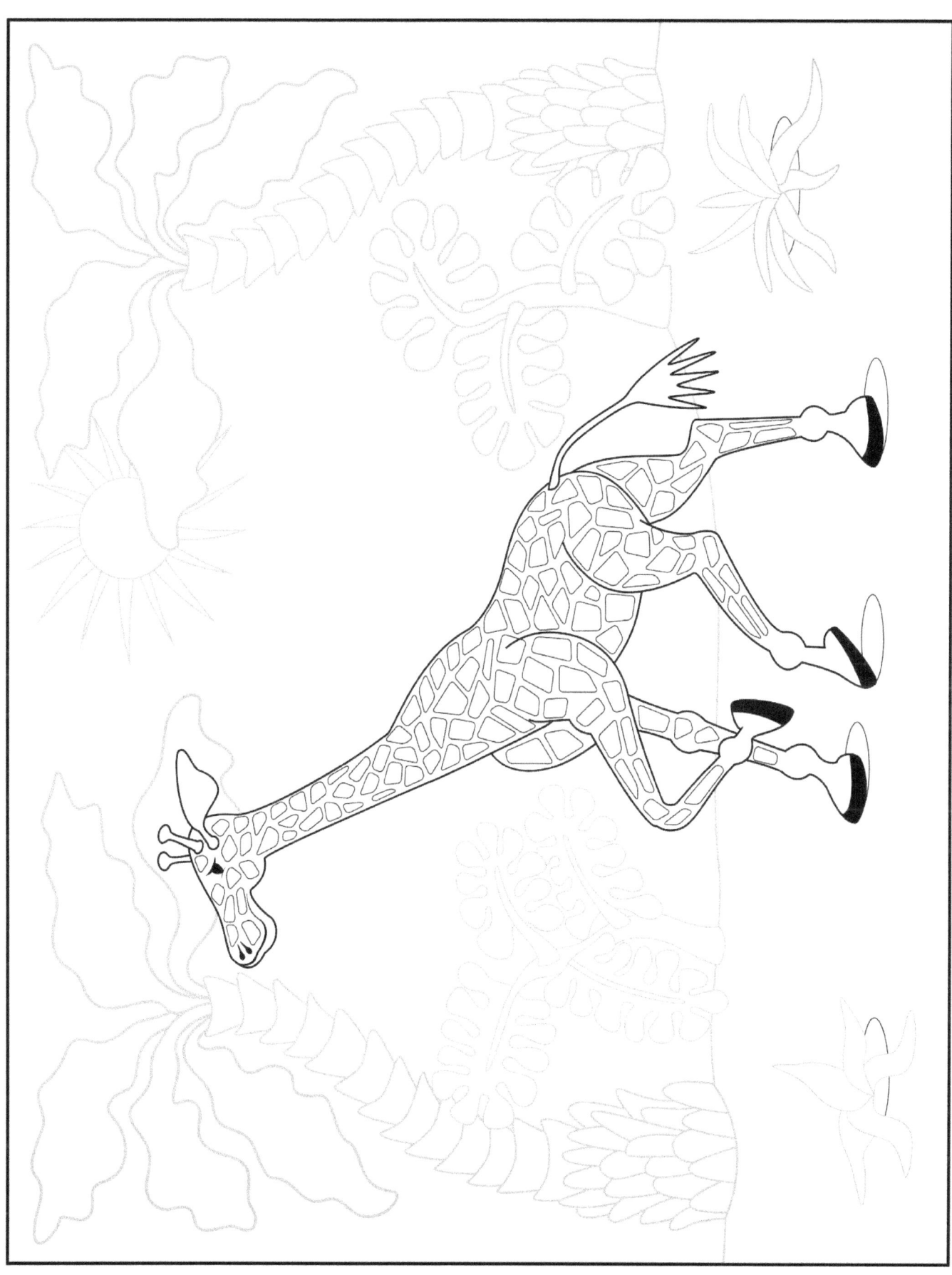

Illustration credit: Bigstockphoto.com: mashabr- 111224213

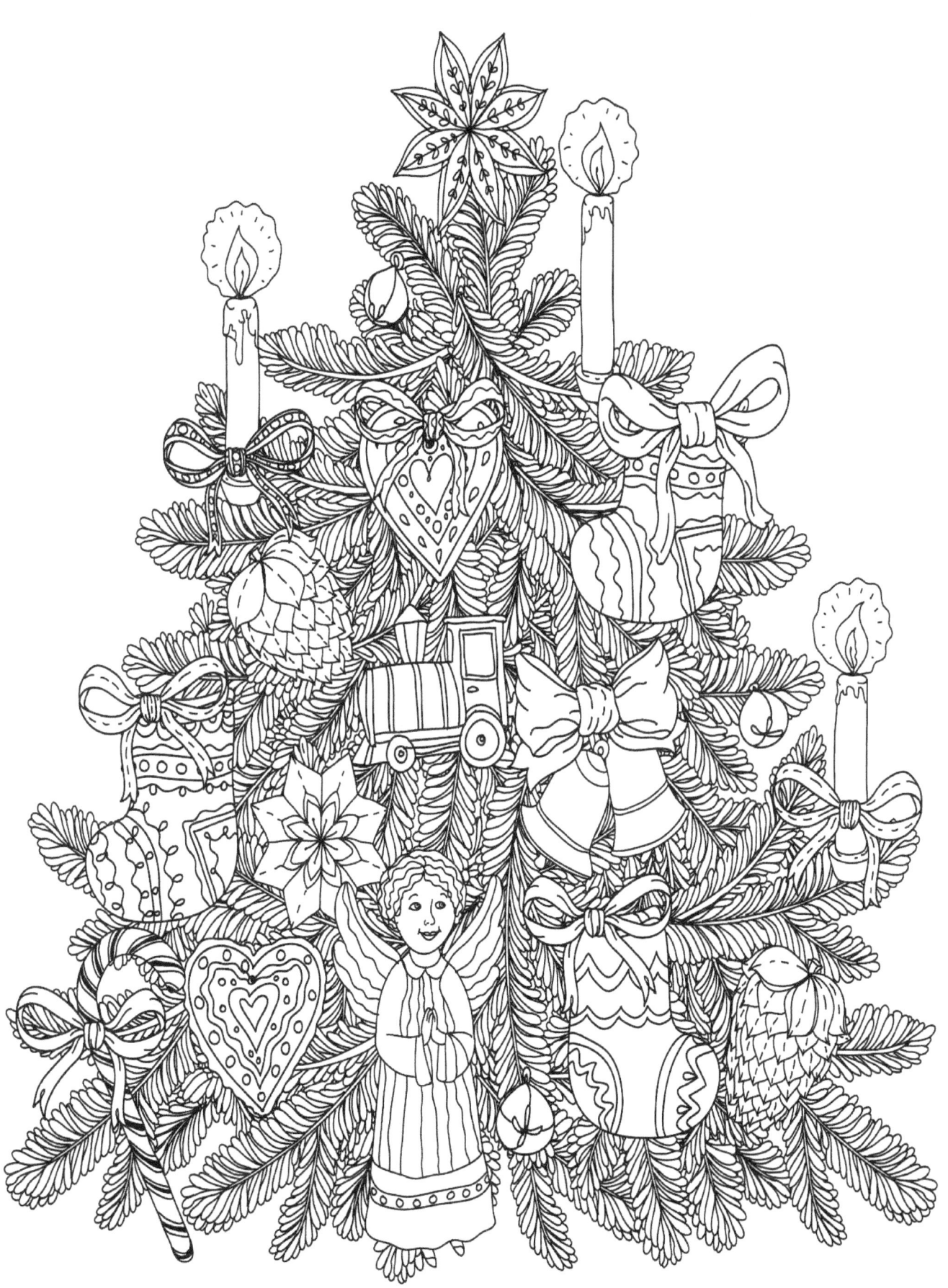

Illustration credit: Bigstockphoto.com: Bimbimkha- 130162982

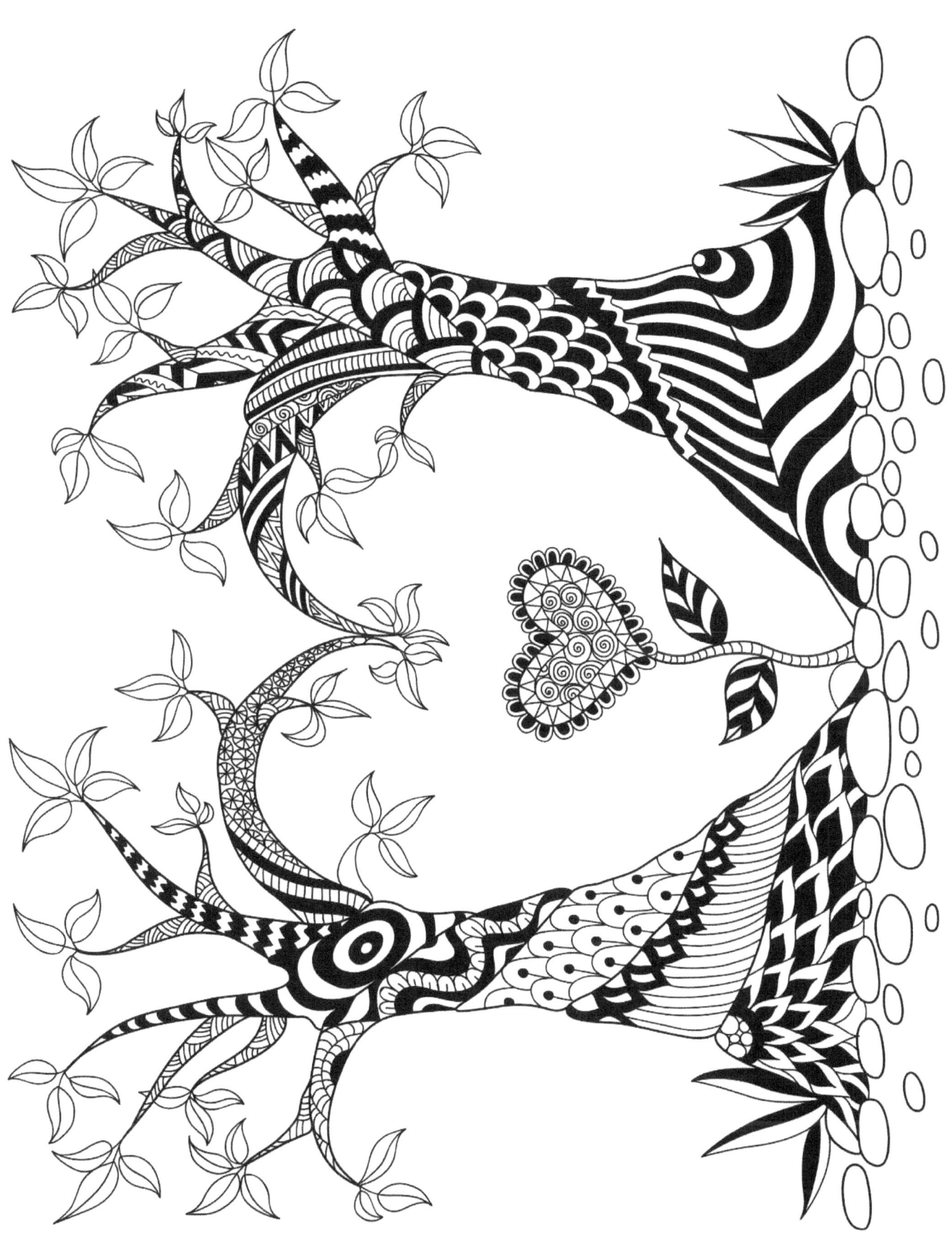

Illustration credit: Bigstockphoto.com: imHope- 136002317

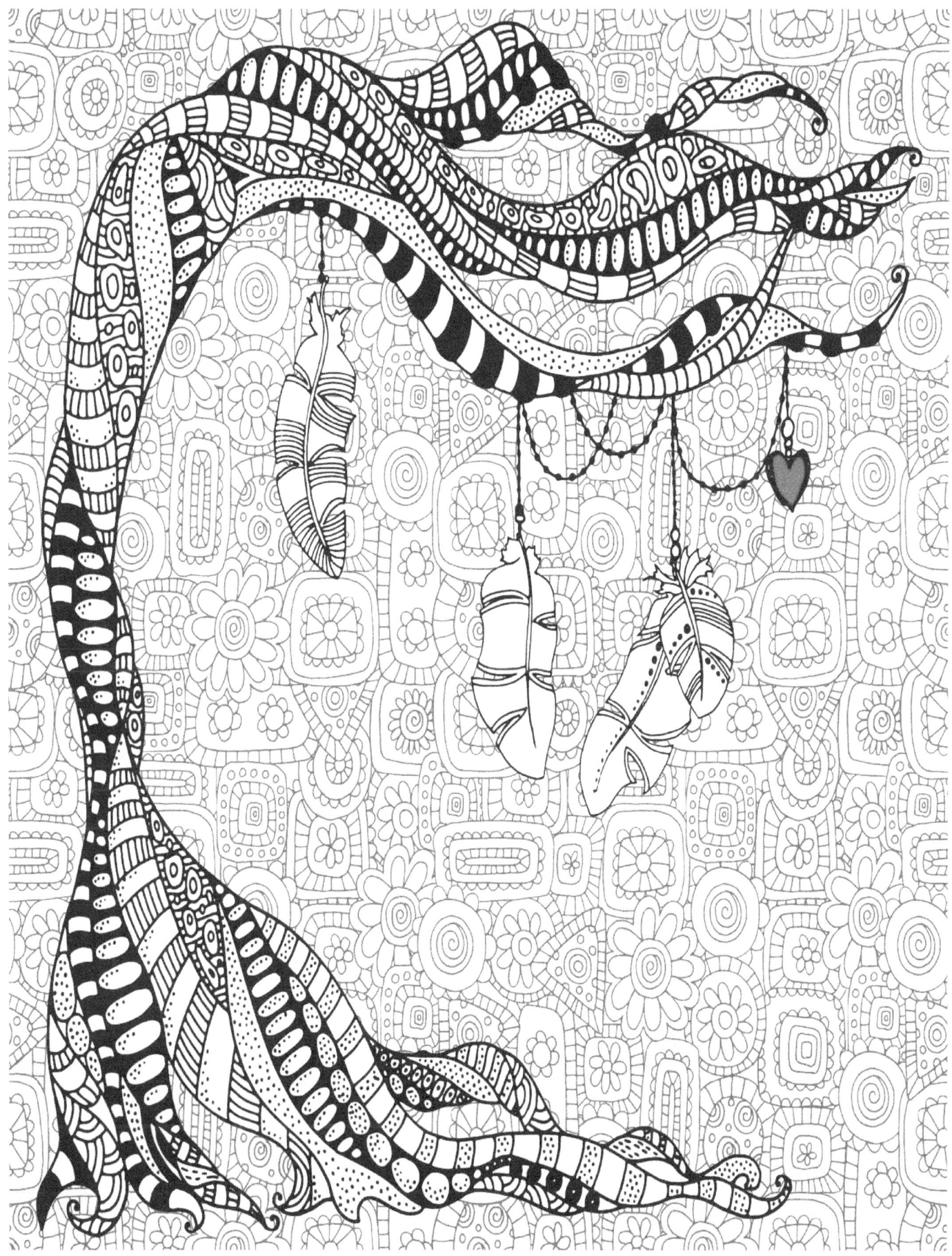

Illustration credit: Bigstockphoto.com: Elenapro- 140829713

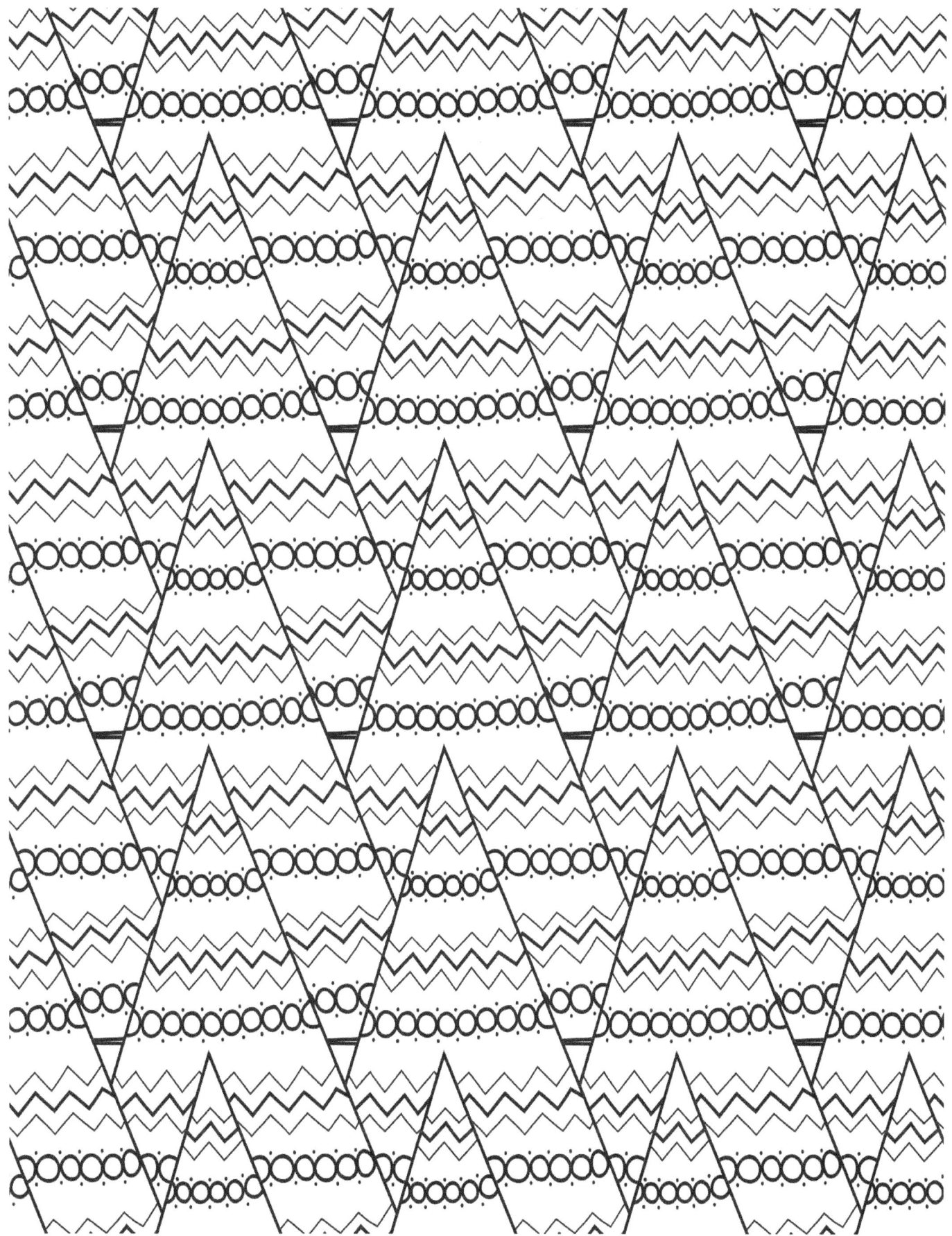

Illustration credit: Bigstockphoto.com: AnnaitSmi- 128236292

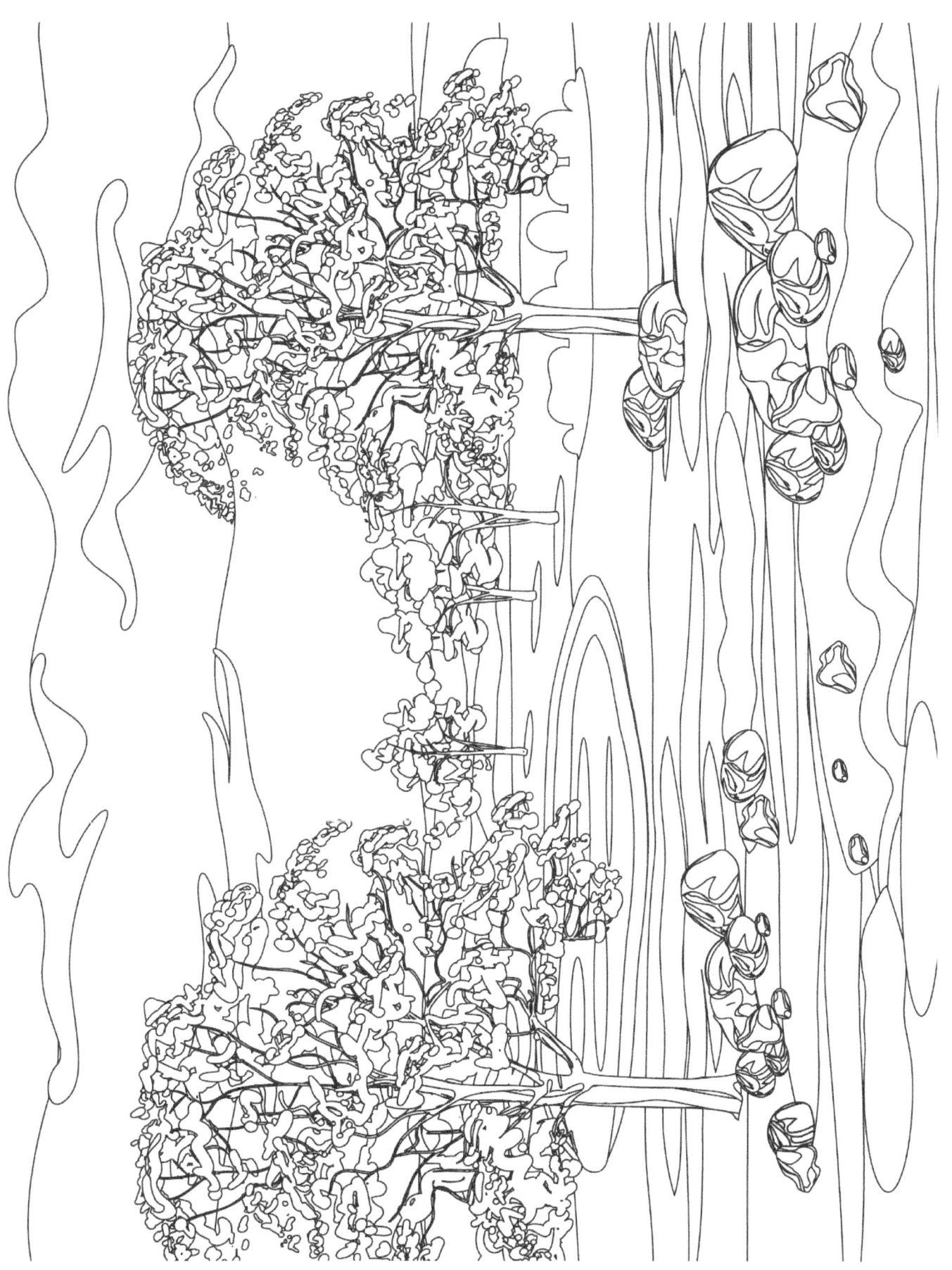

Illustration credit: Bigstockphoto.com: juiliyas- 137826839

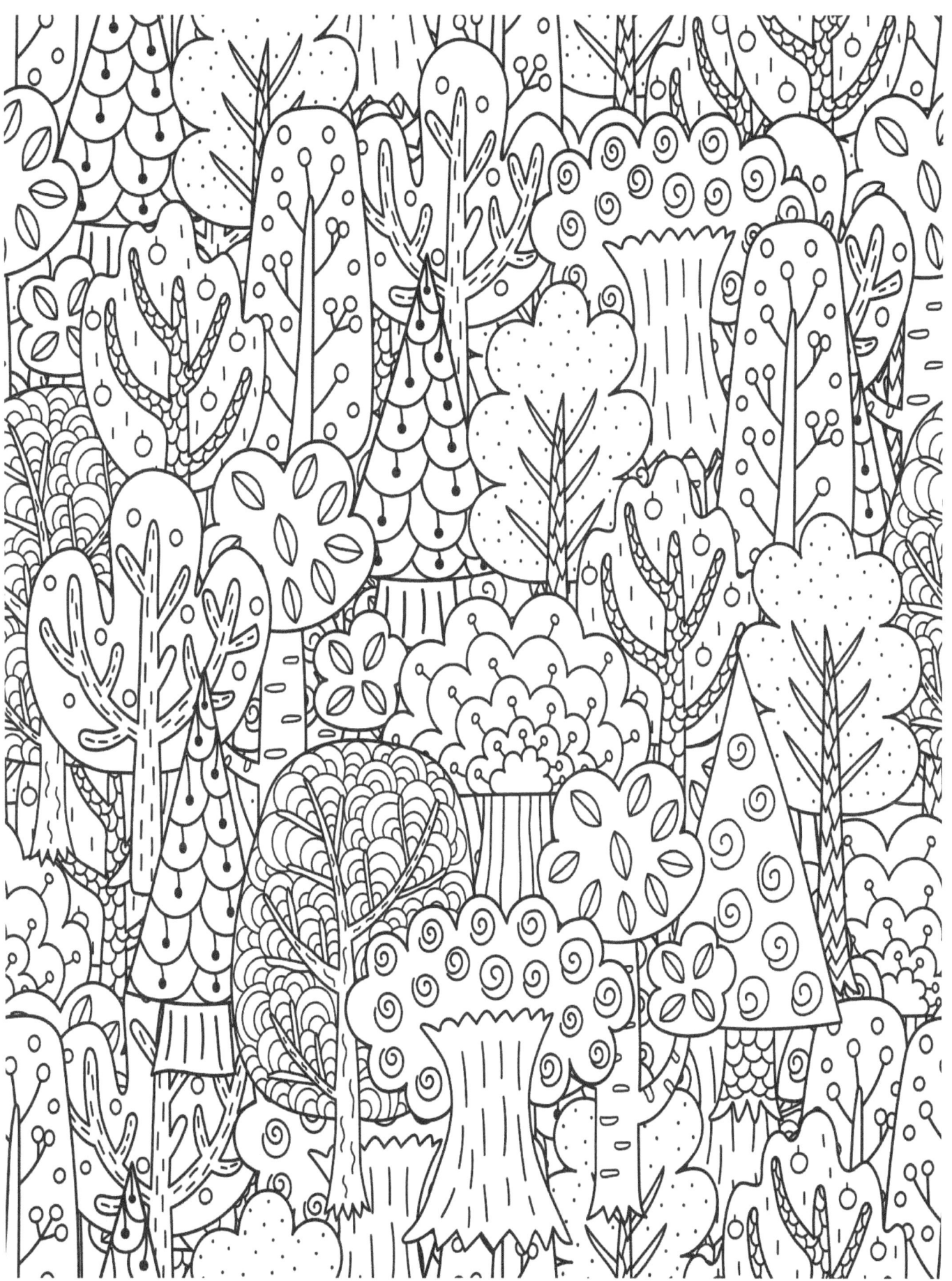

Illustration credit: Bigstockphoto.com: YAZZIK- 131666945

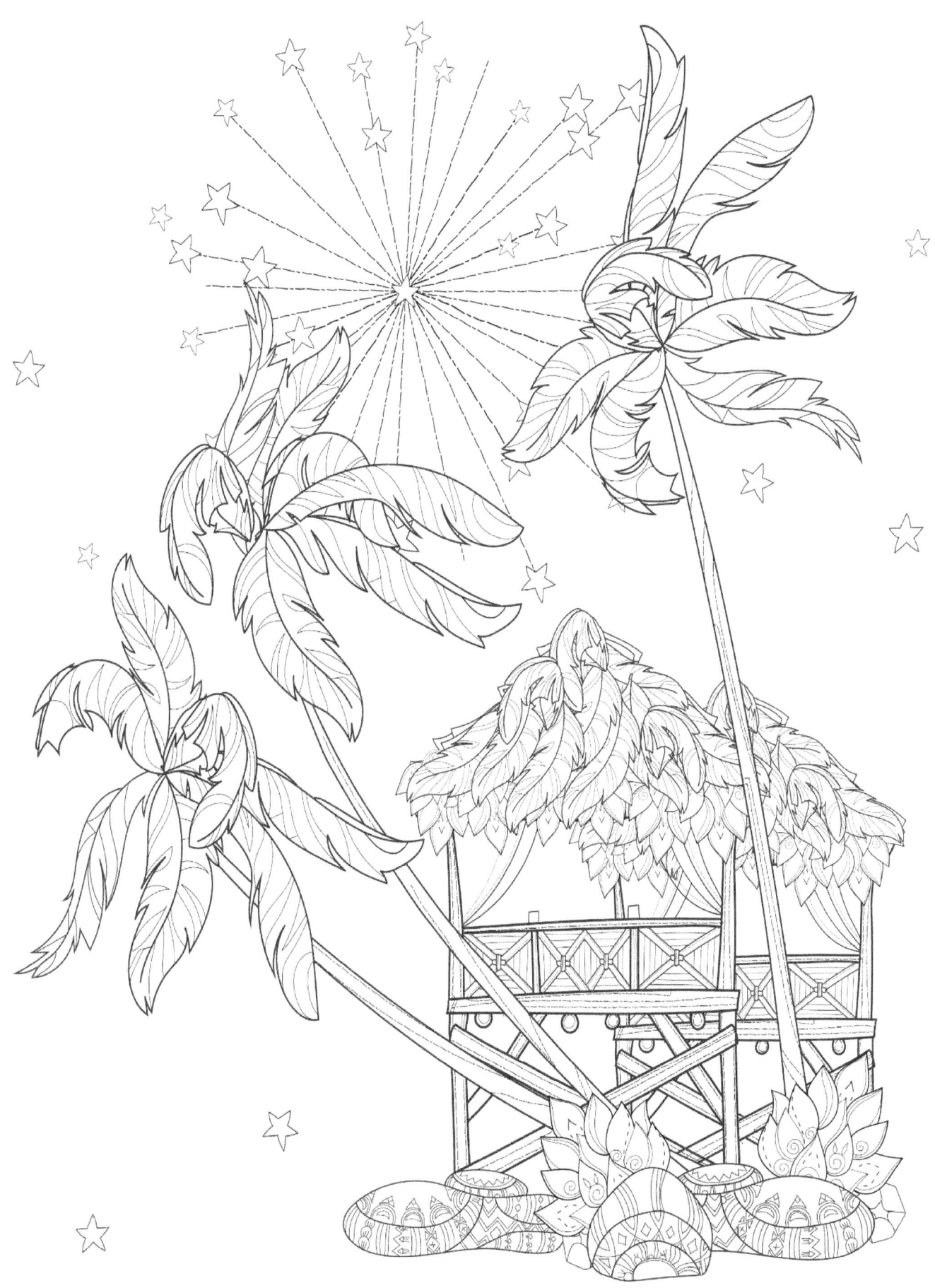

Illustration credit: Bigstockphoto.com:totallypic- 129374333

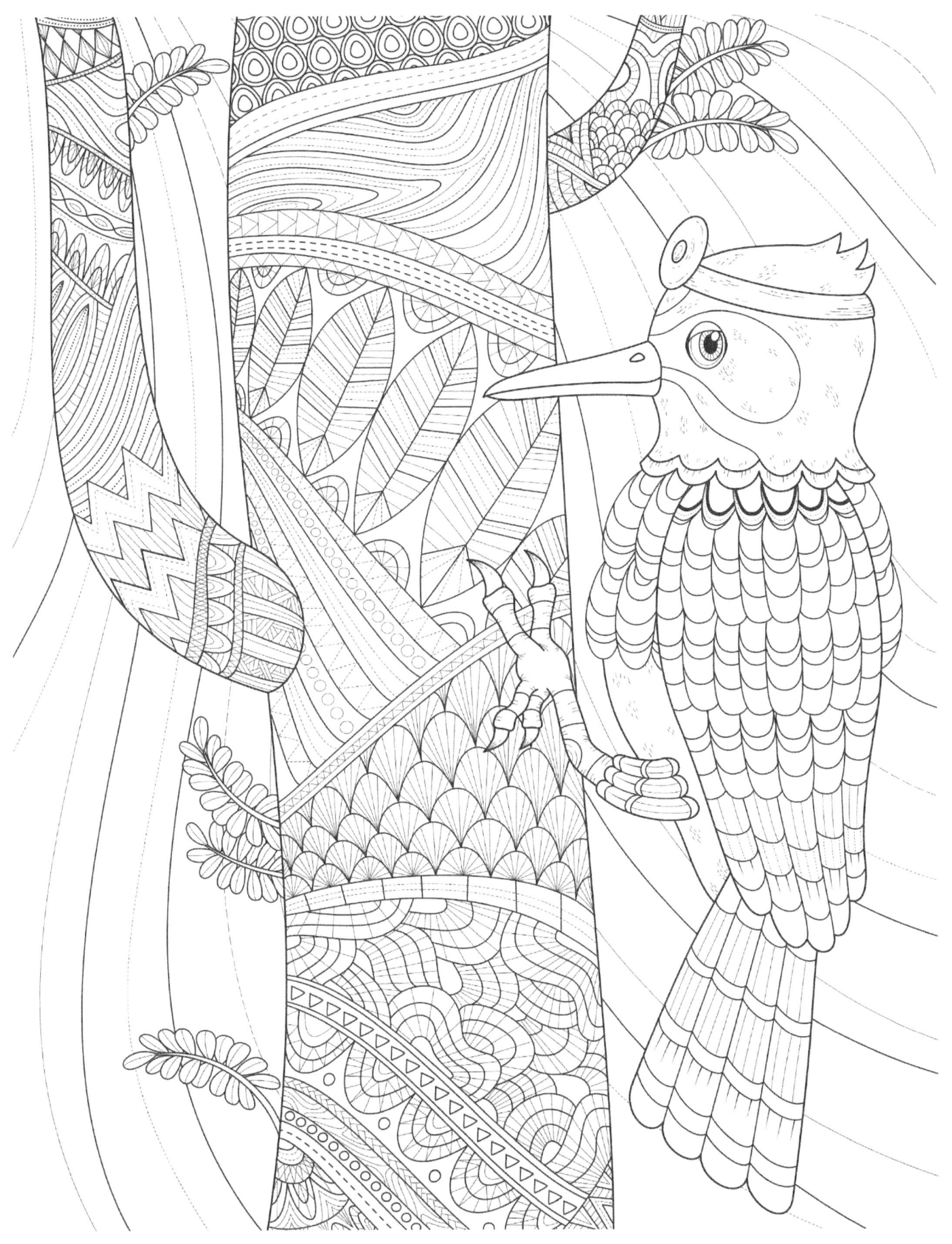

Illustration credit: Bigstockphoto.com:AlexBannykh- 8062392

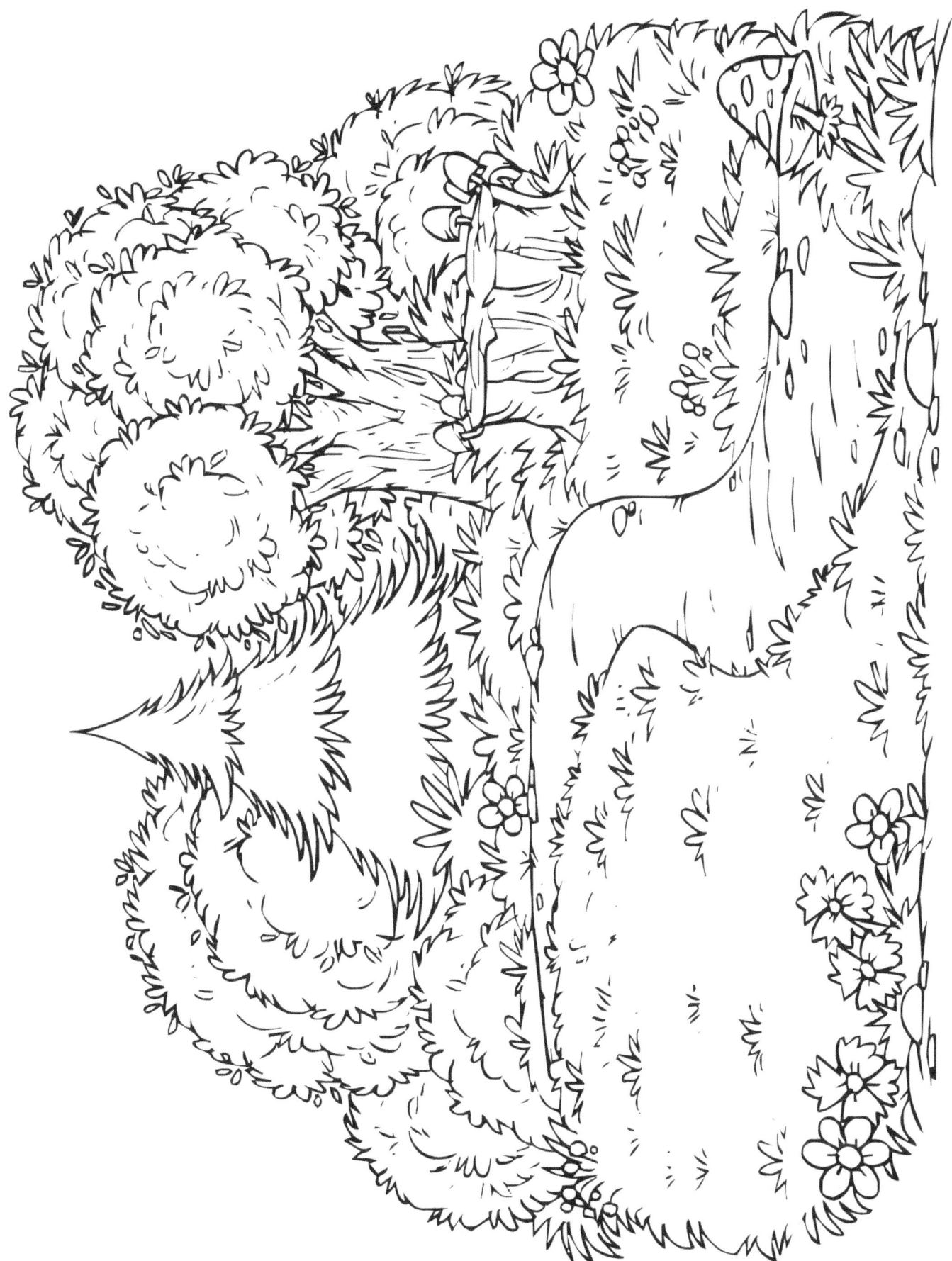

Illustration credit: Bigstockphoto.com: imHope- 136002263

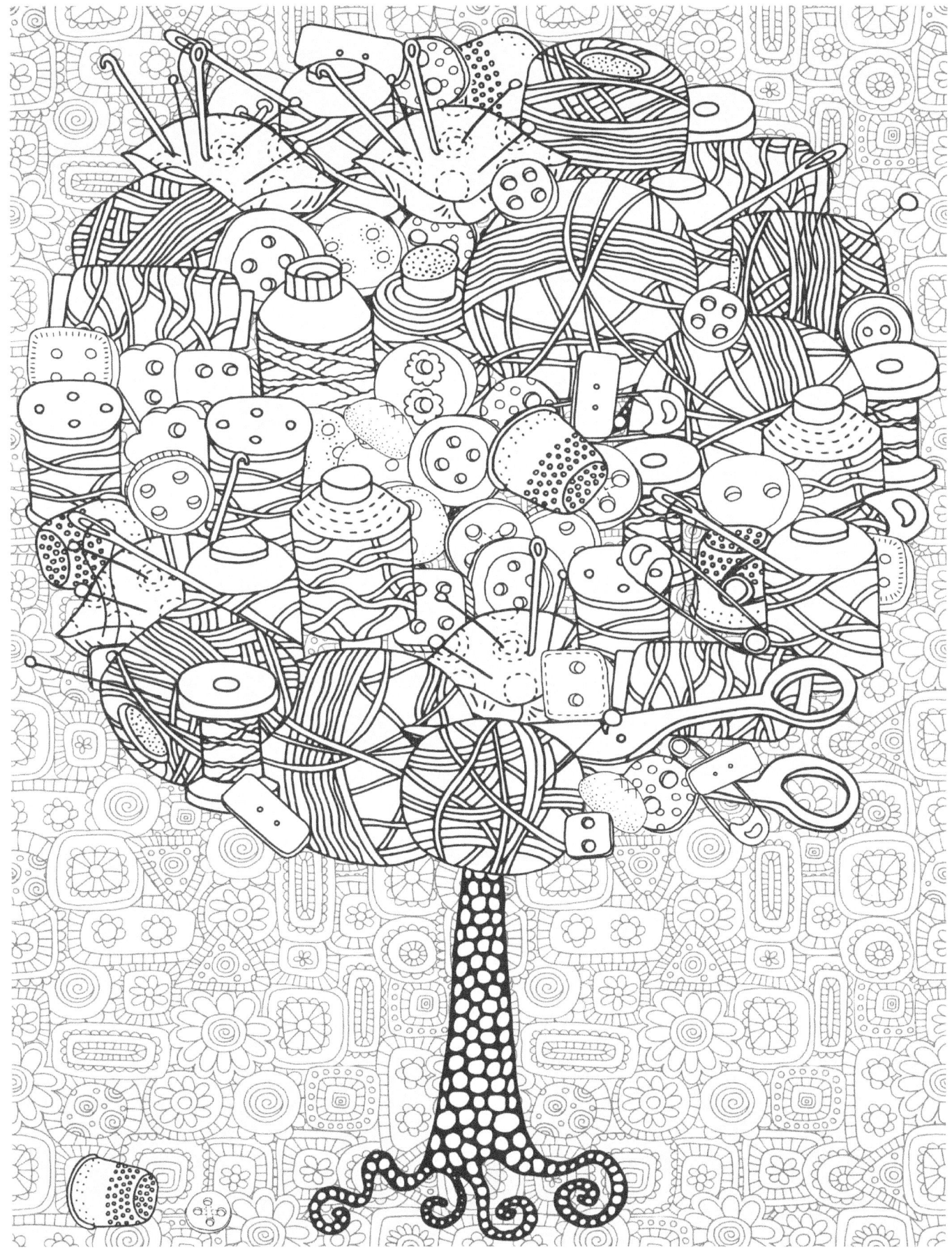

Illustration credit: Bigstockphoto.com: totallypic- 138521465

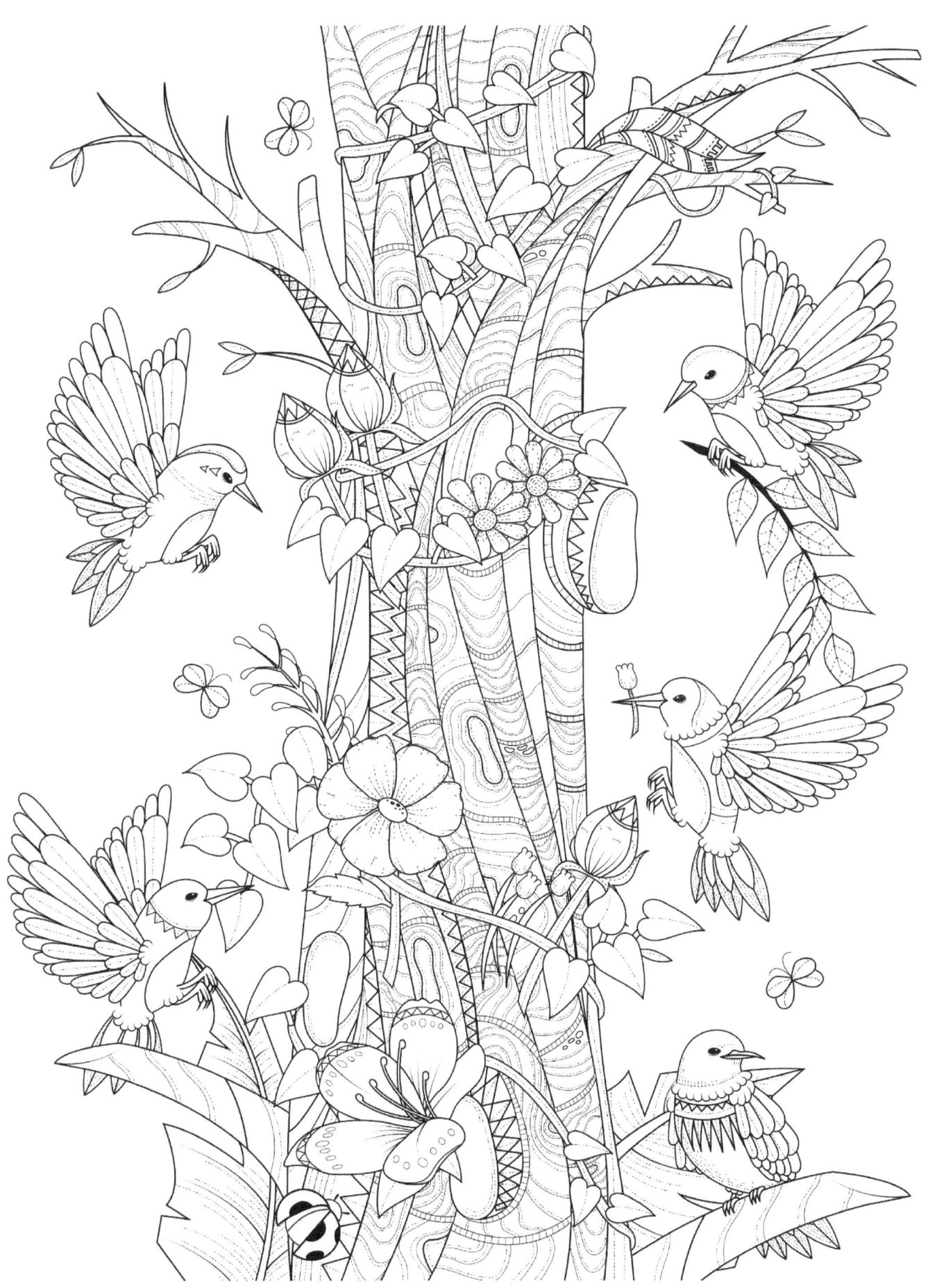

Illustration credit: Bigstockphoto.com: imHope:-136305050

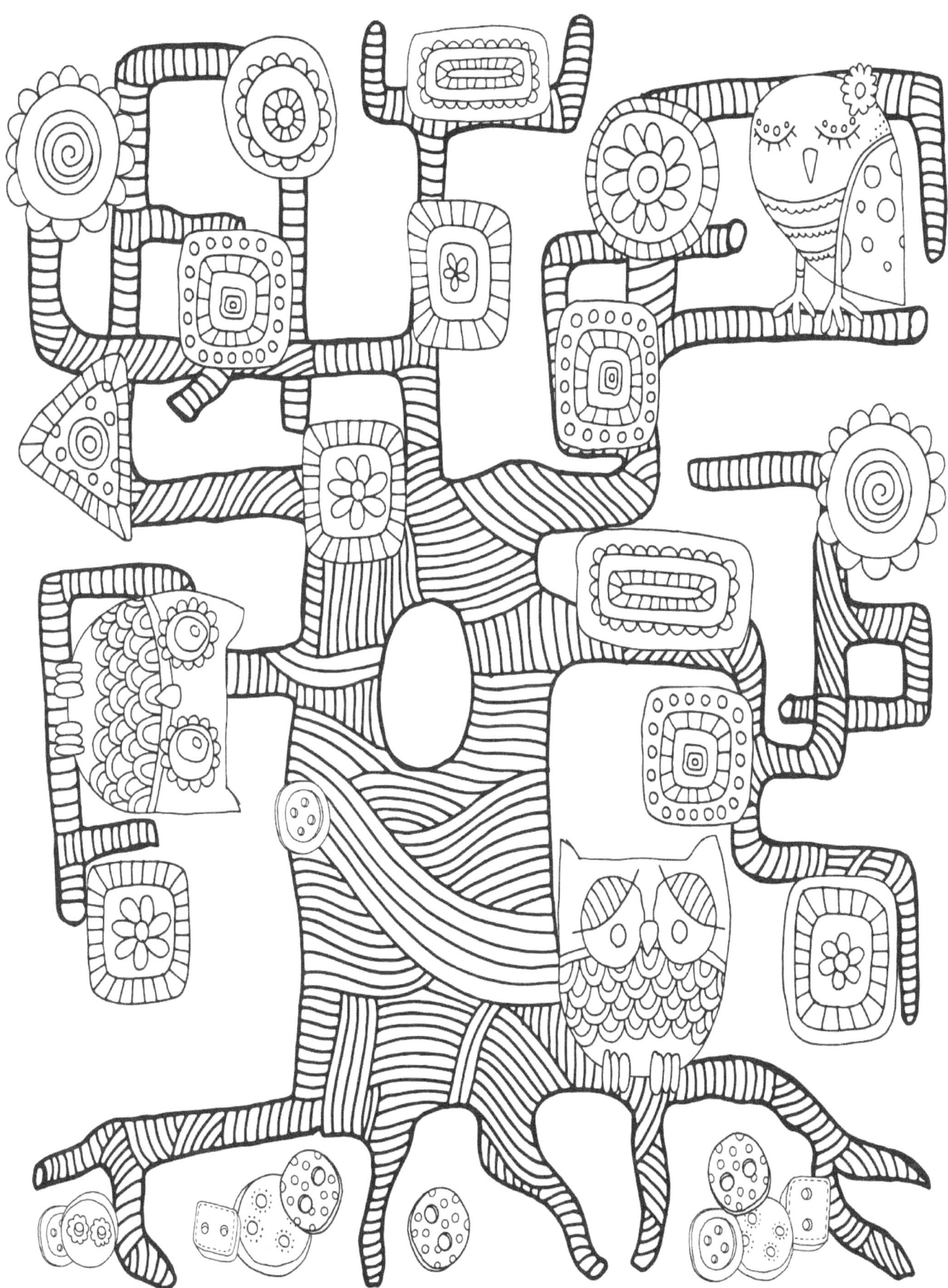

Illustration credit: Bigstockphoto.com: Katrin Snow -135487169

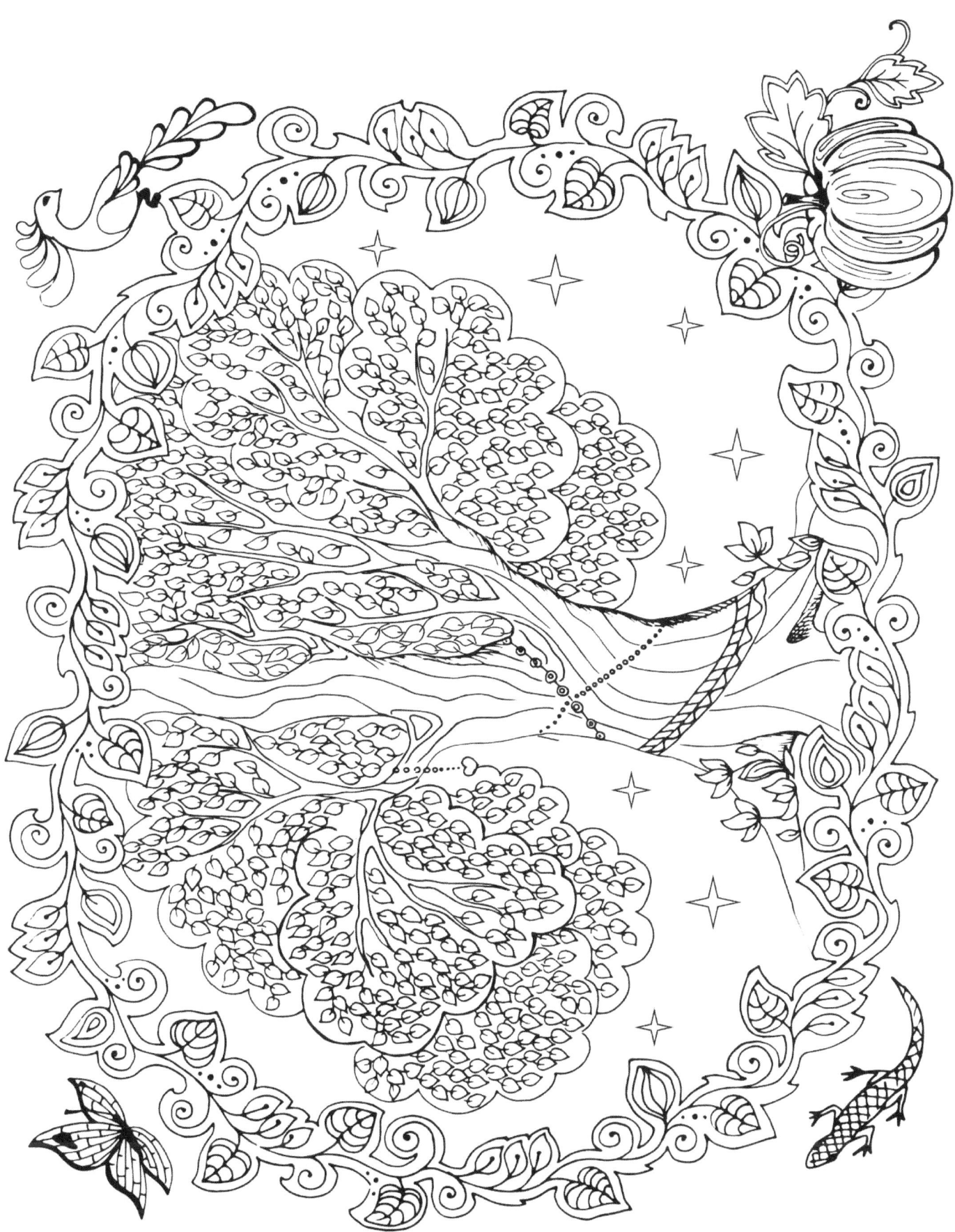

Illustration credit: Bigstockphoto.com: totallypic- 129374327

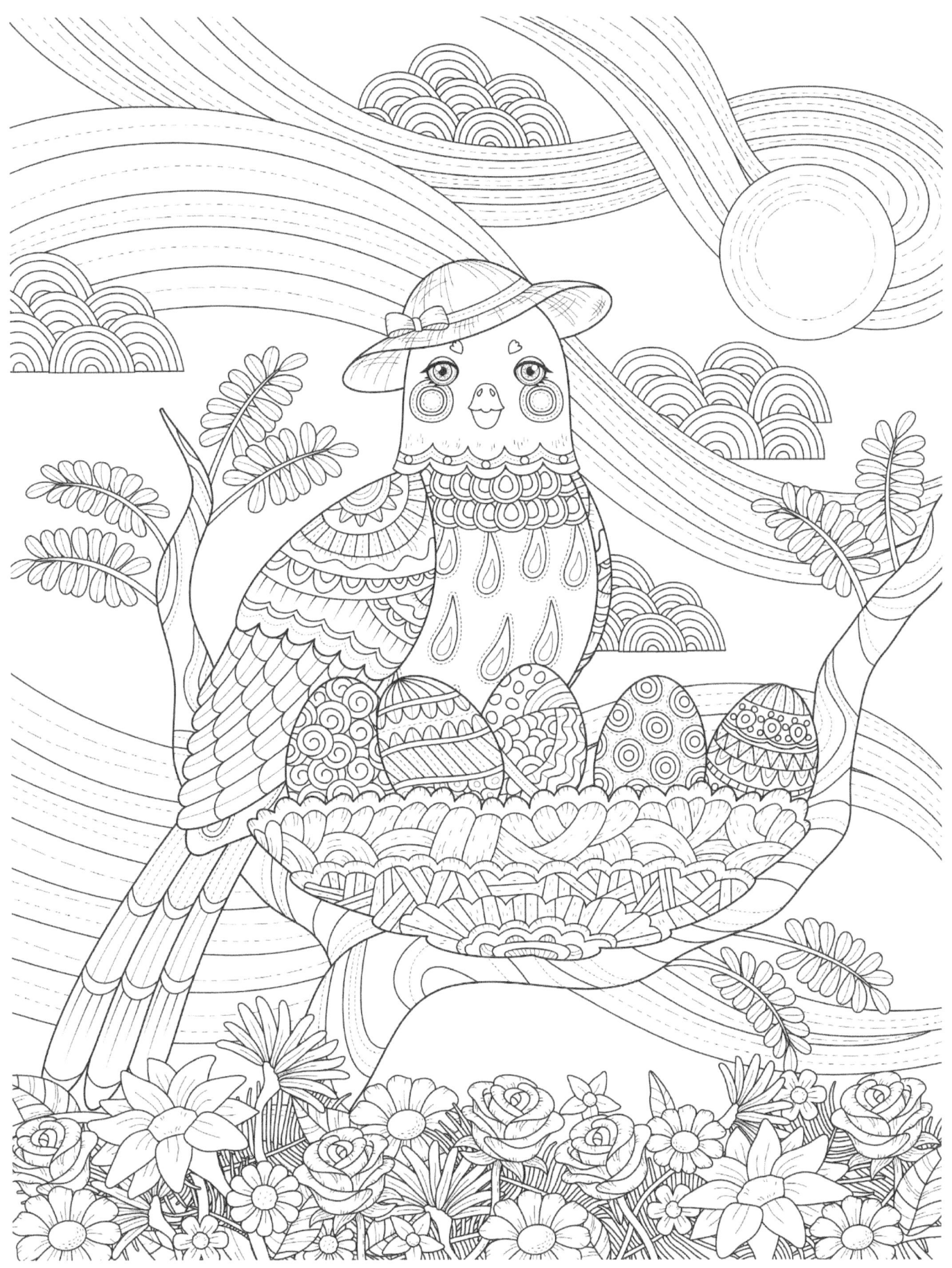

Illustration credit: Bigstockphoto.com: Val_Iva- 123606095

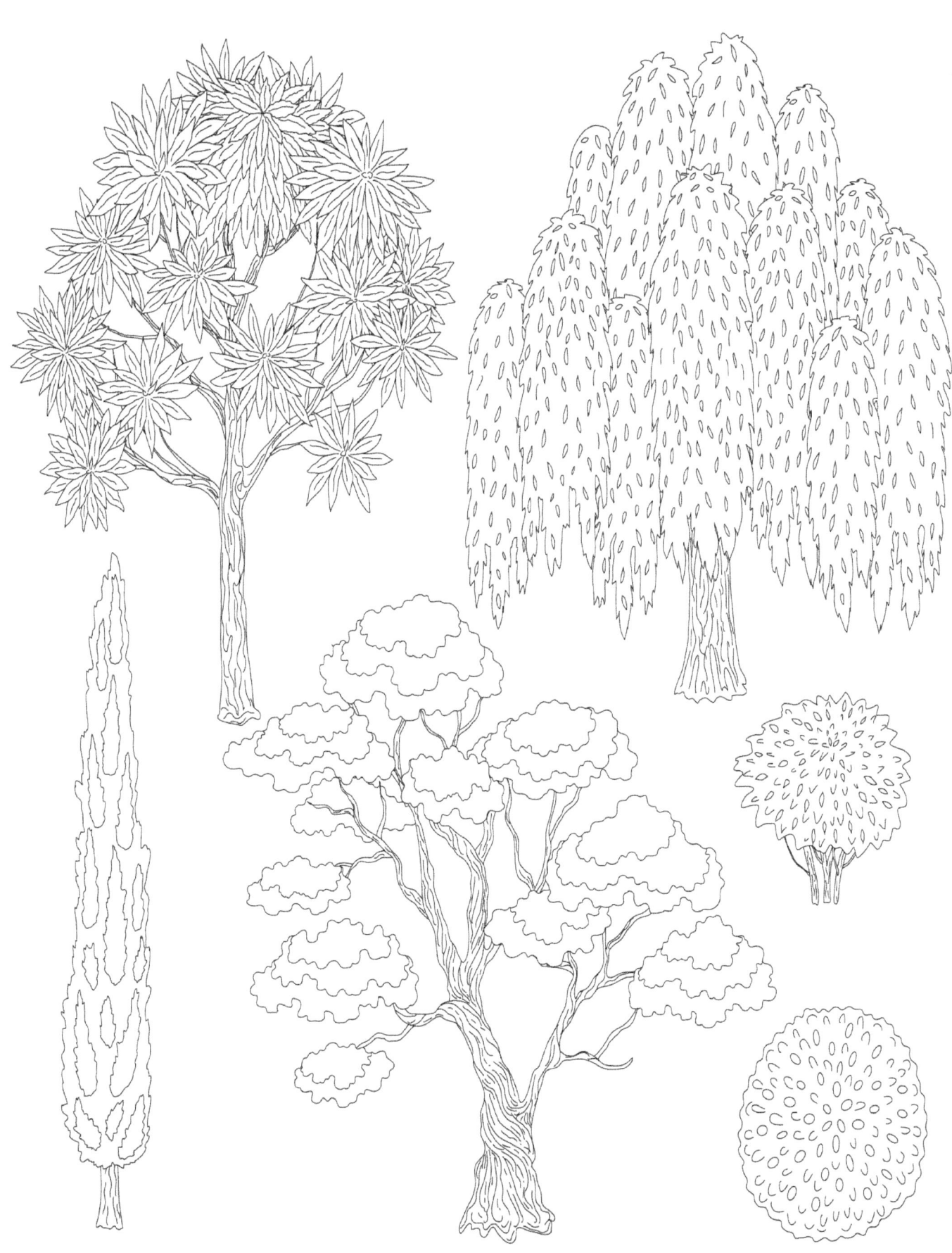

Illustration credit: Bigstockphoto.com: Elenapro- 139140803

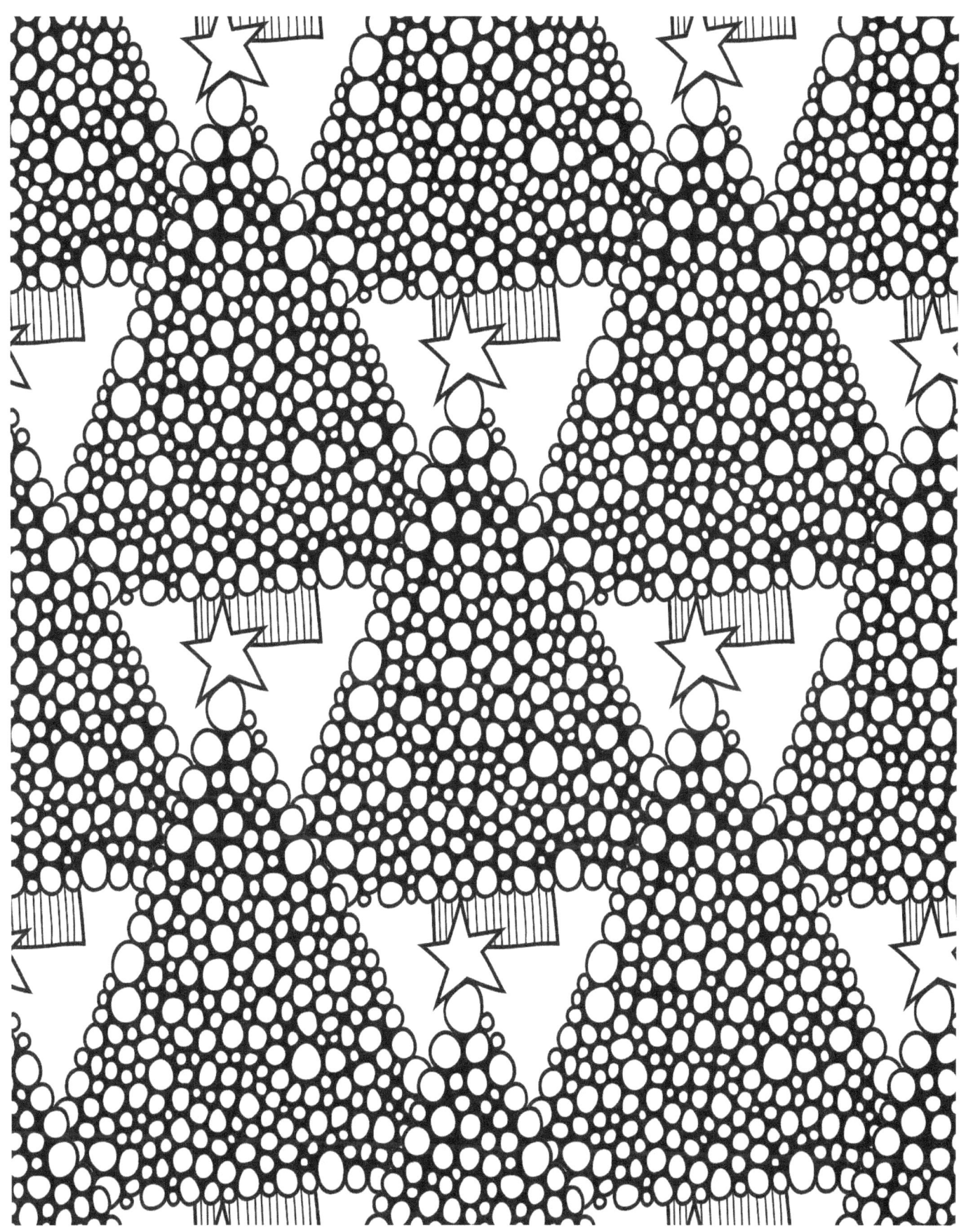

Illustration credit: Bigstockphoto.com: Sybirko- 123939137

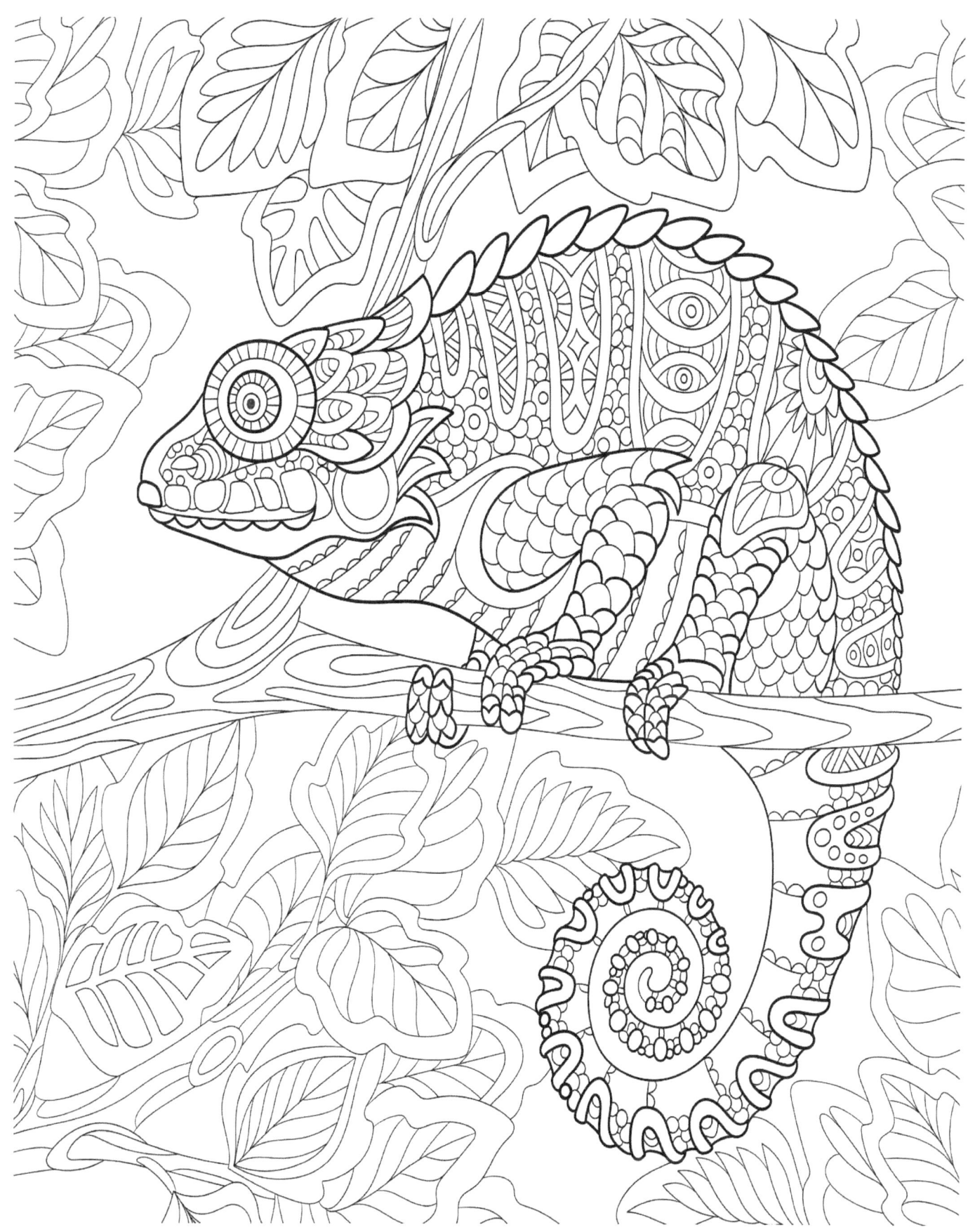

Illustration credit: Bigstockphoto.com: imHope-135379826

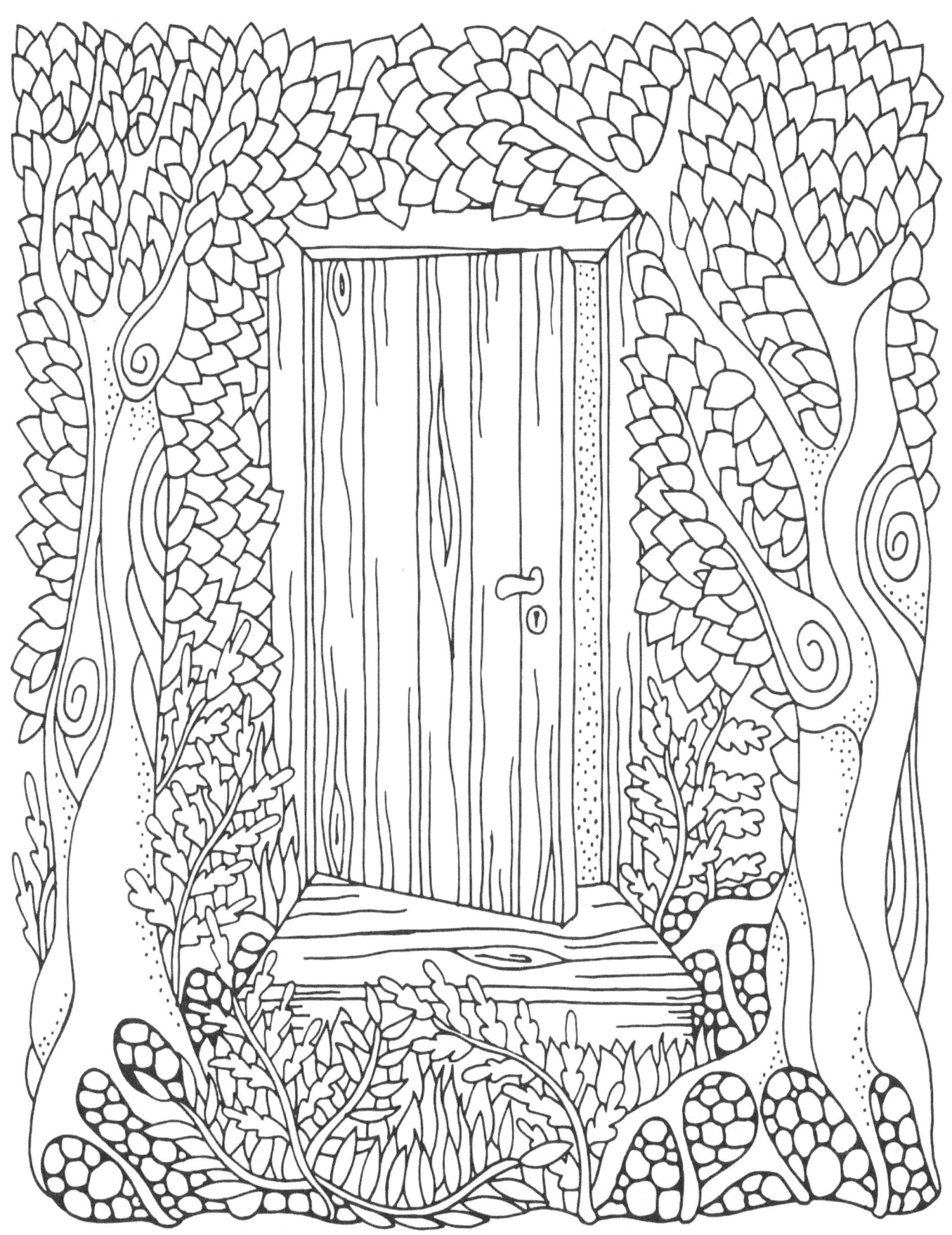

Illustration credit: Bigstockphoto.com: Bimbimkha- 122366501

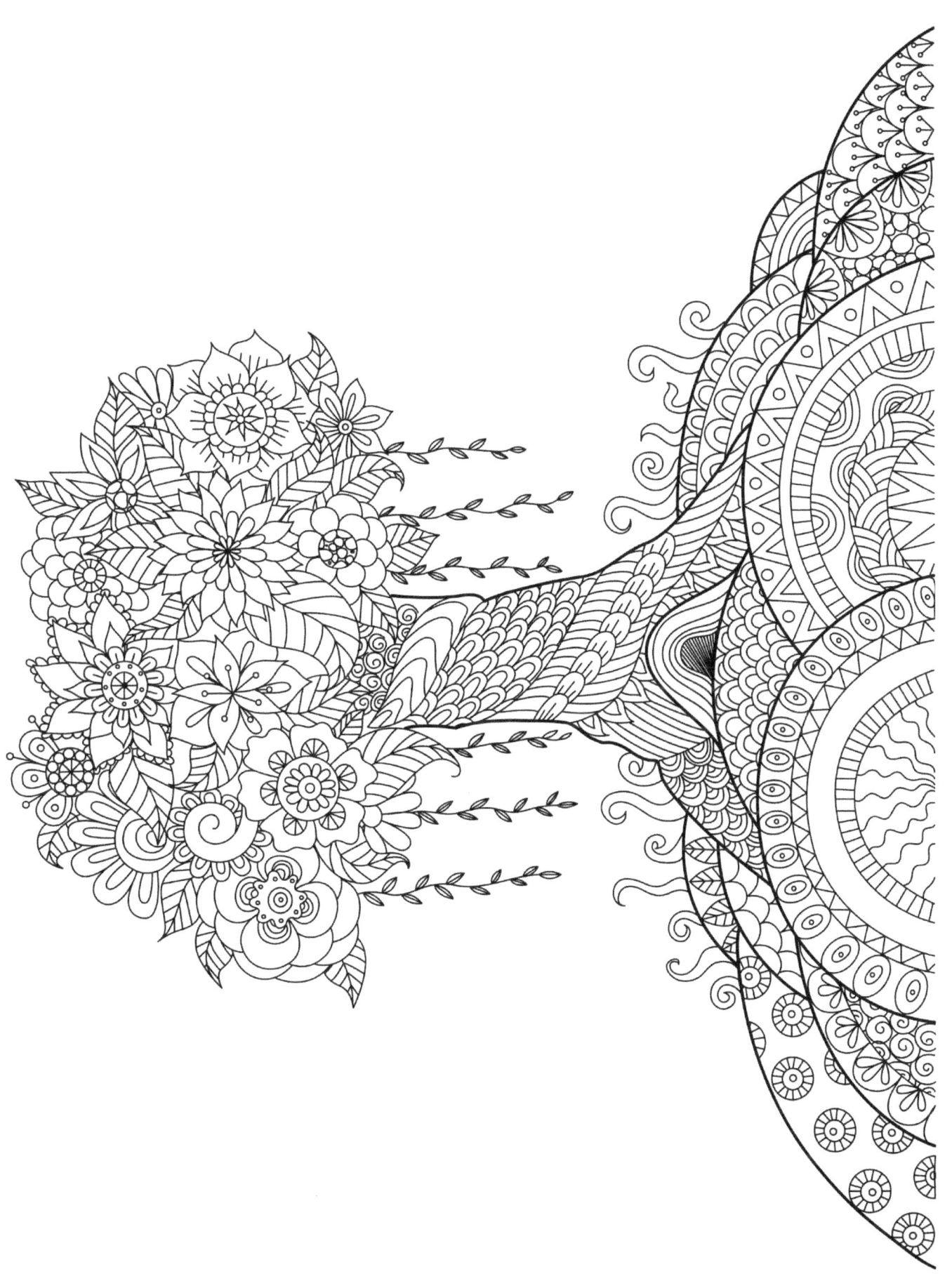

Illustration credit: Bigstockphoto.com: juliyas- 137831847

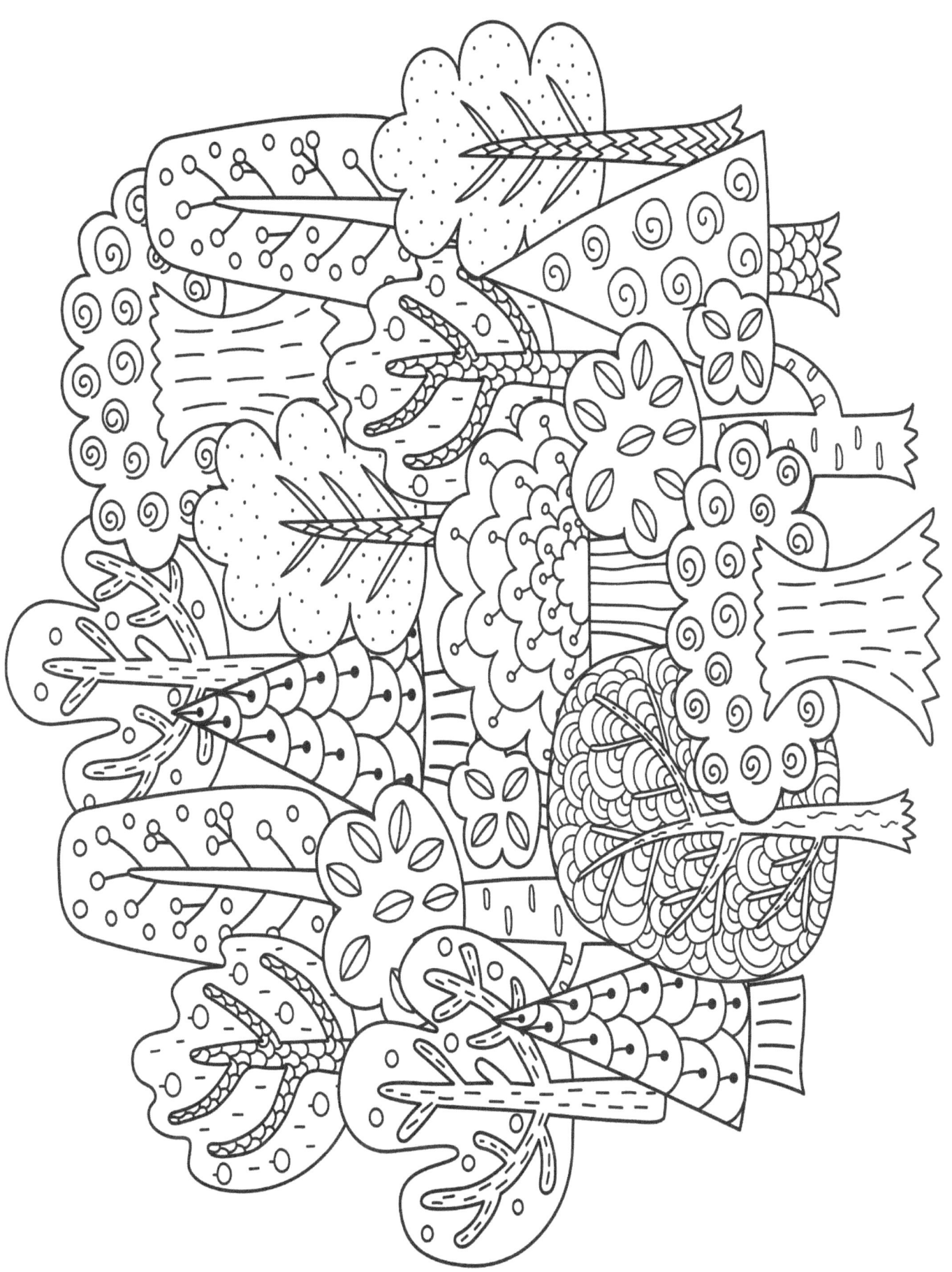

Illustration credit: Bigstockphoto.com: imHope-136001897

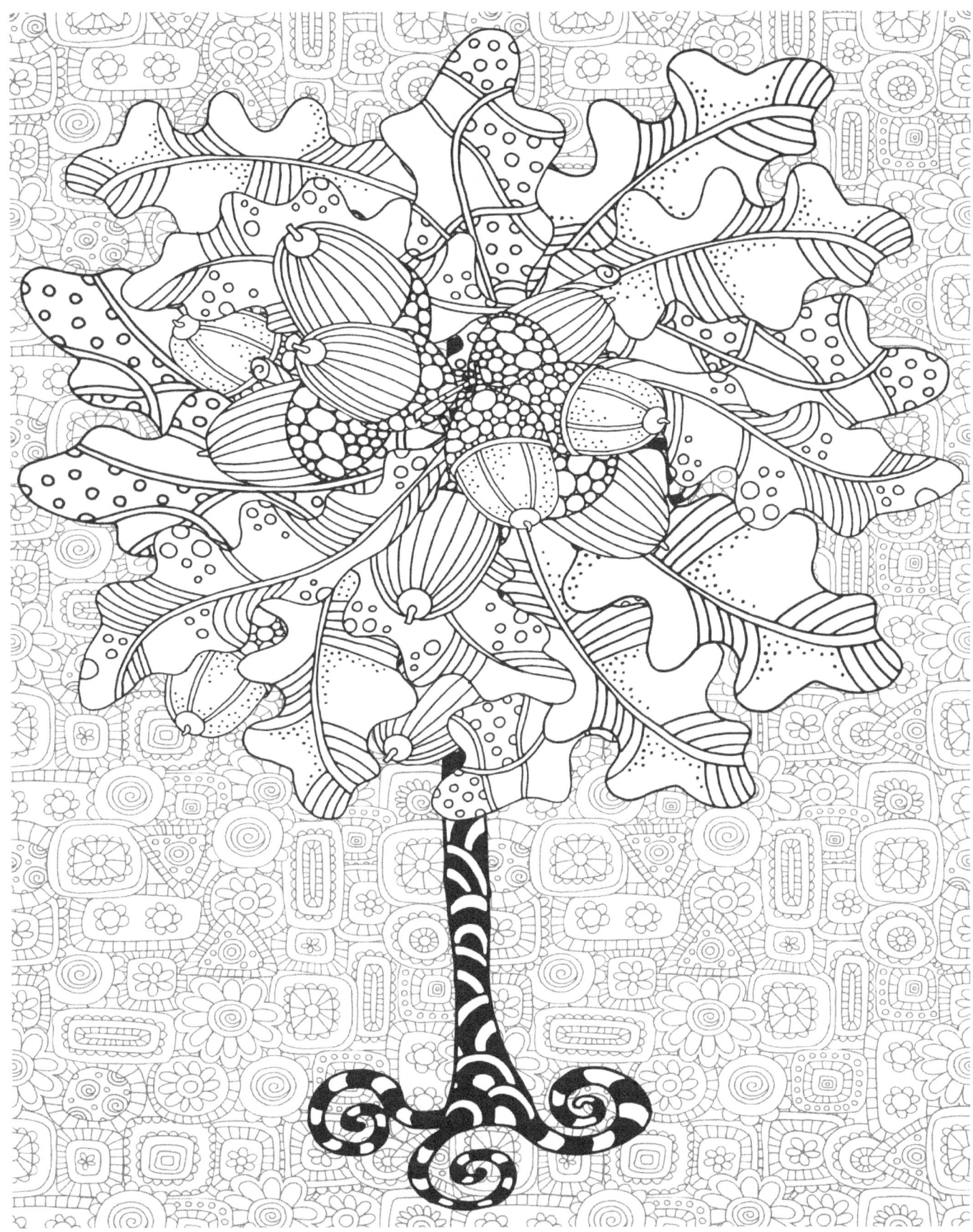

Illustration credit: Bigstockphoto.com: frescomovie- 123585863

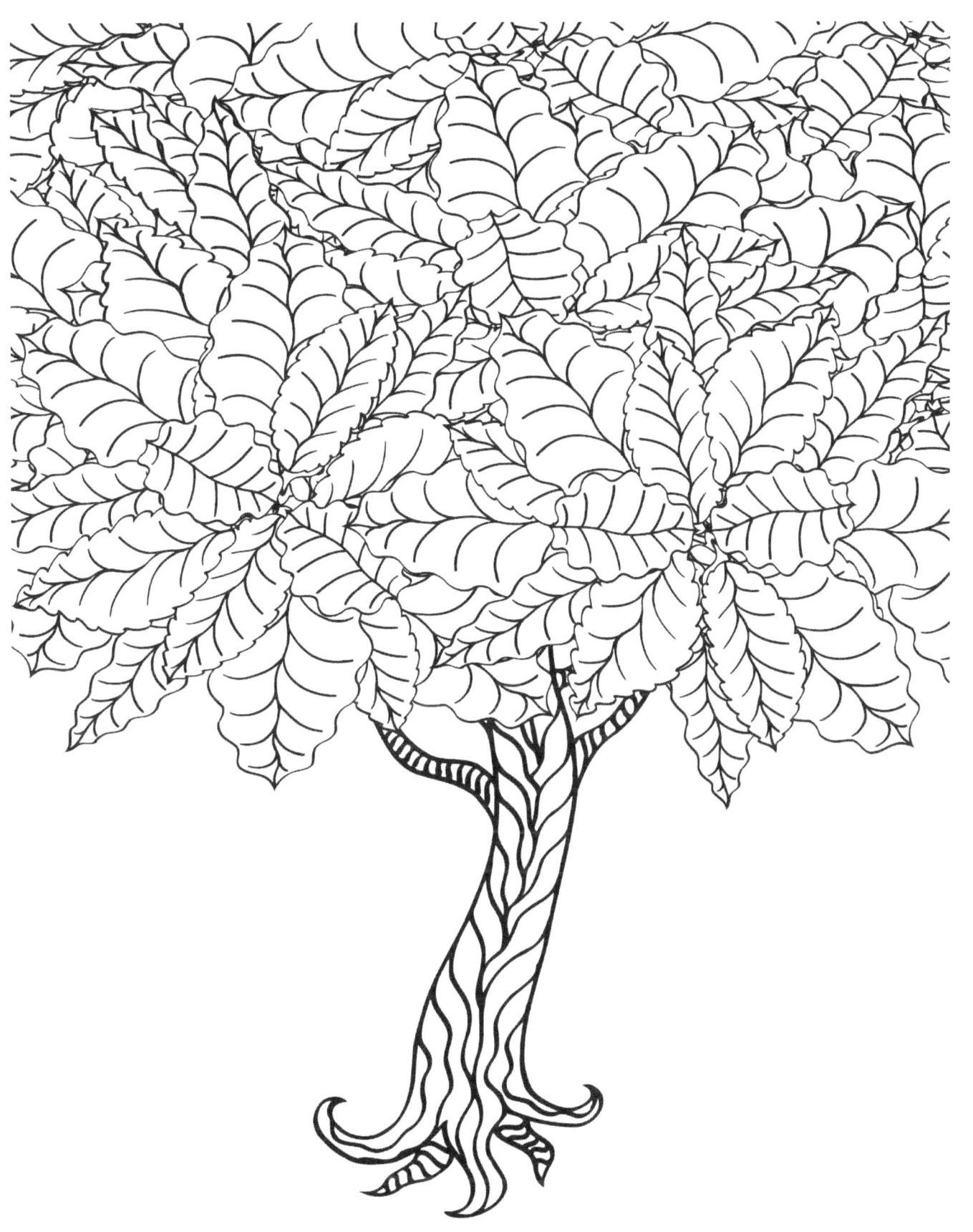

Illustration credit: Bigstockphoto.com: AlexBannykh- 108063674

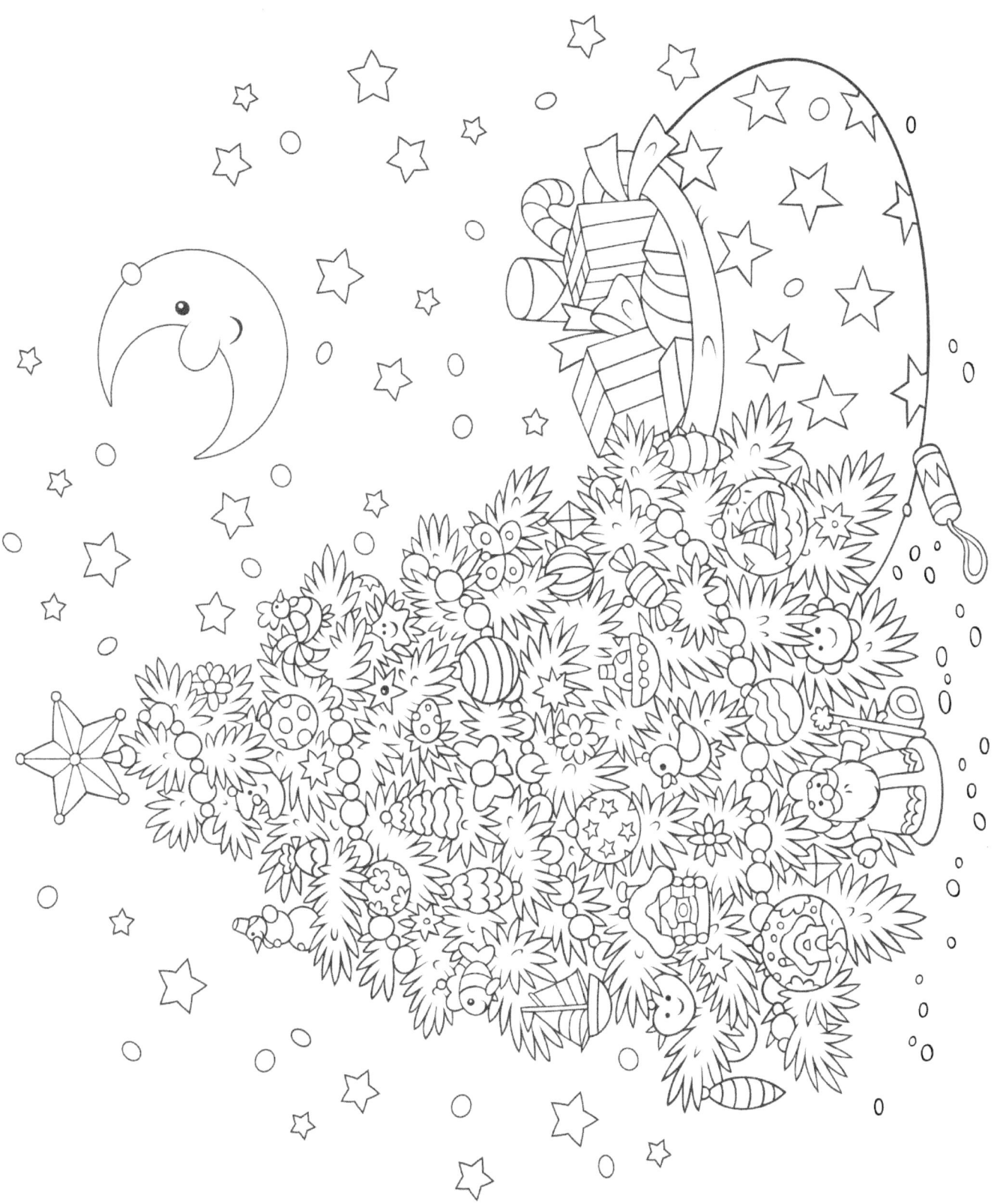

Illustration credit: Bigstockphoto.com: AlexBannykh- 8062394

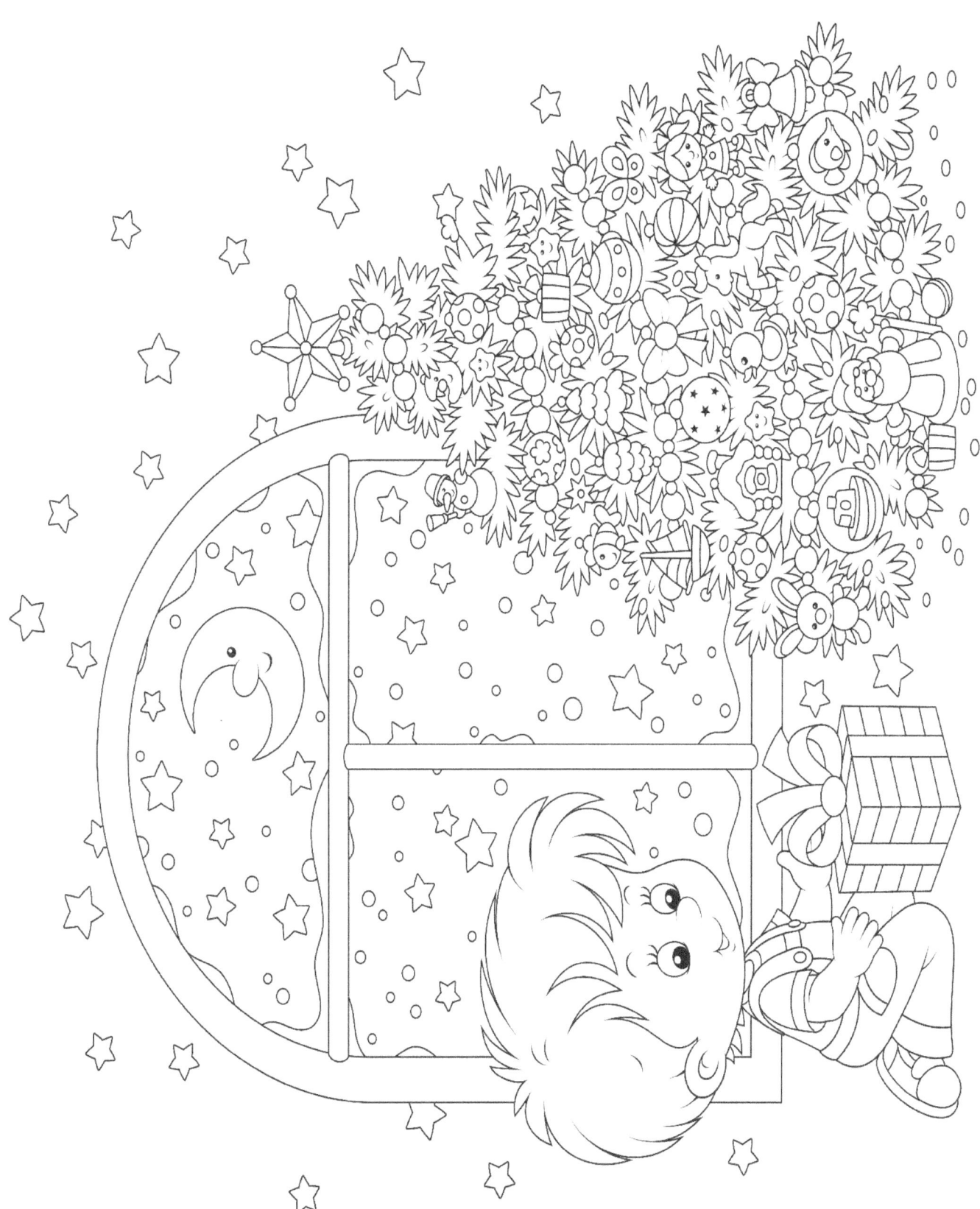

Illustration credit: Bigstockphoto.com: YAZZIK: 130948833

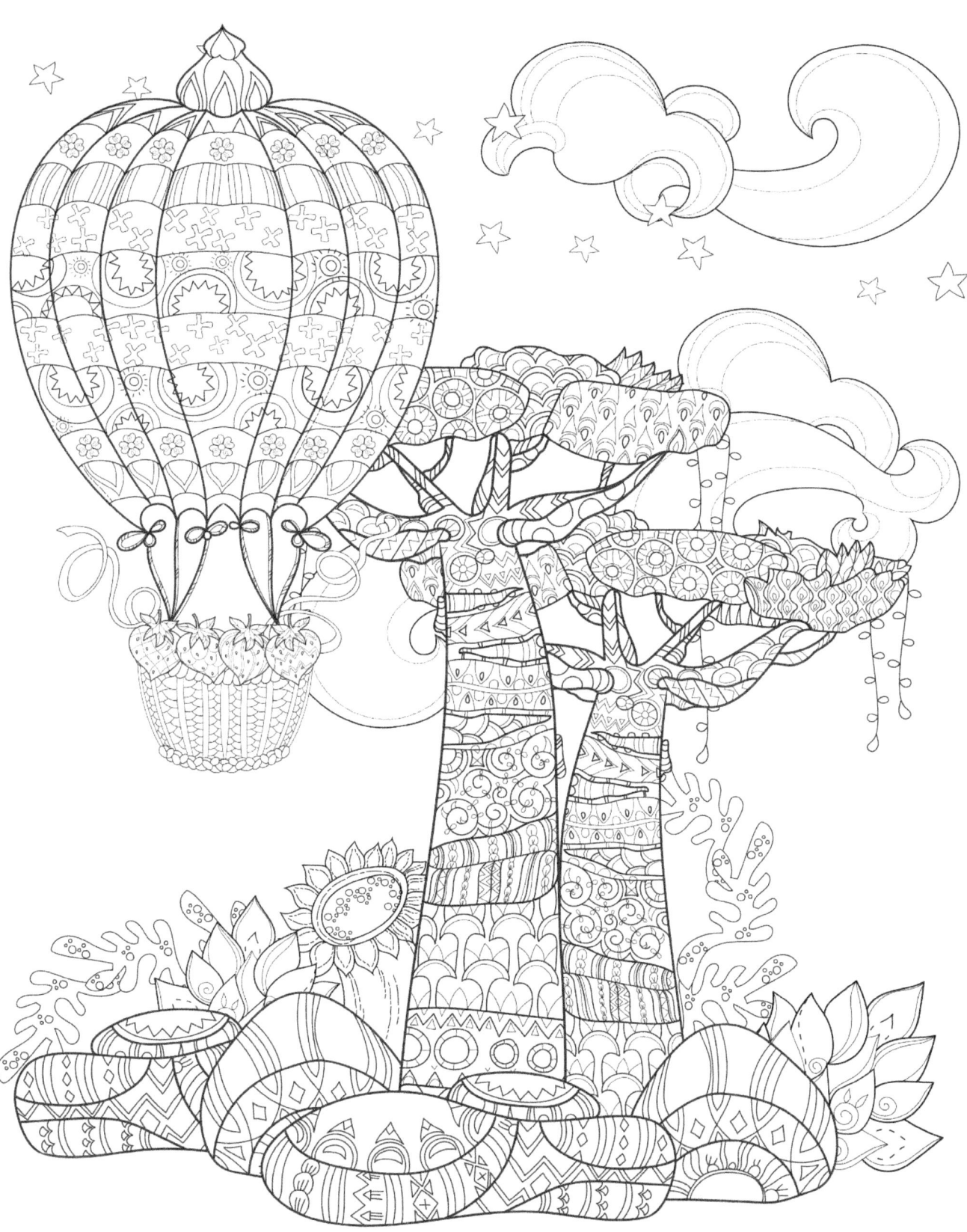

Illustration credit: Bigstockphoto.com: luaeva- 129329588

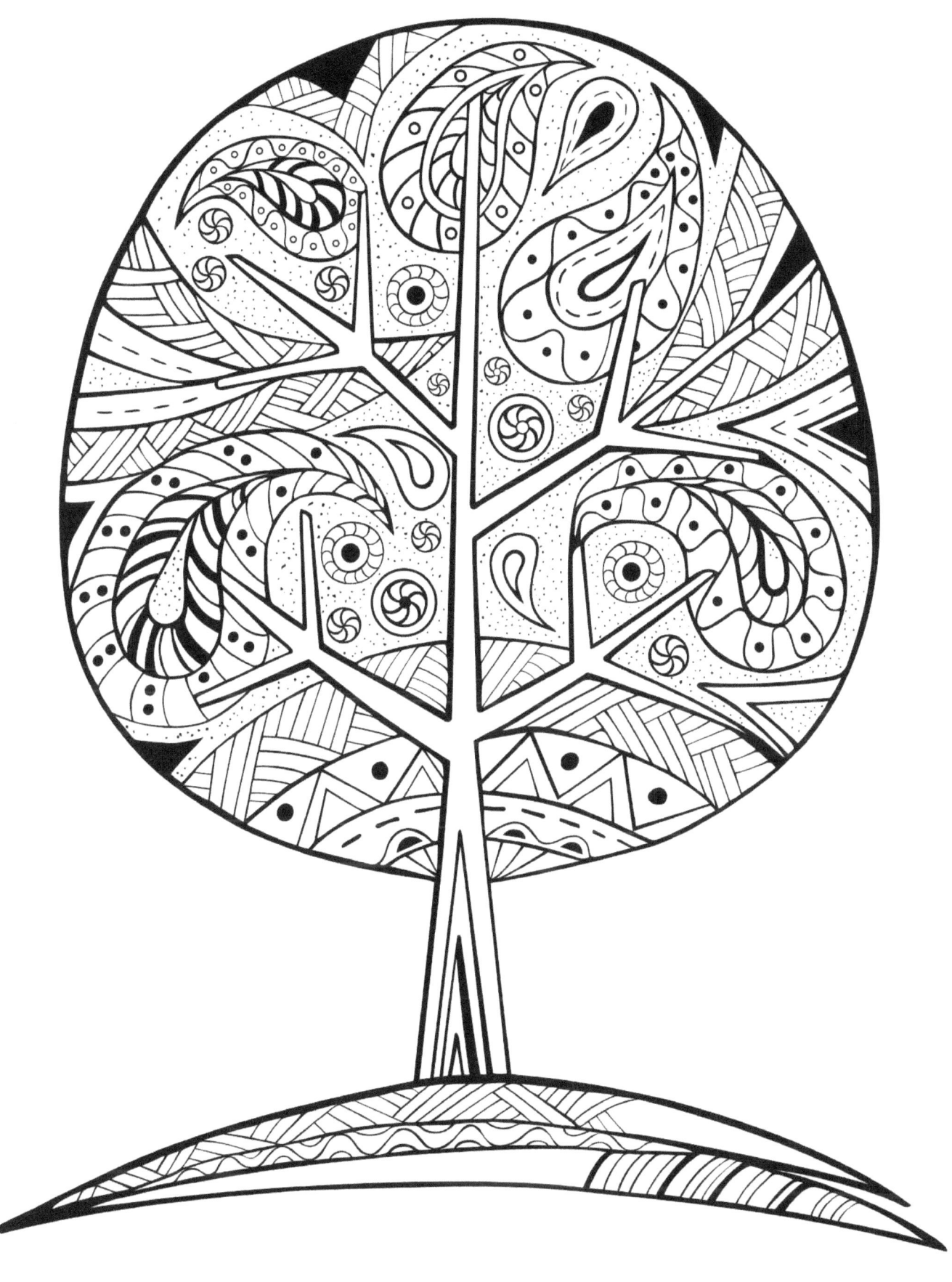

Illustration credit: Bigstockphoto.com: VectorGift: 125749367

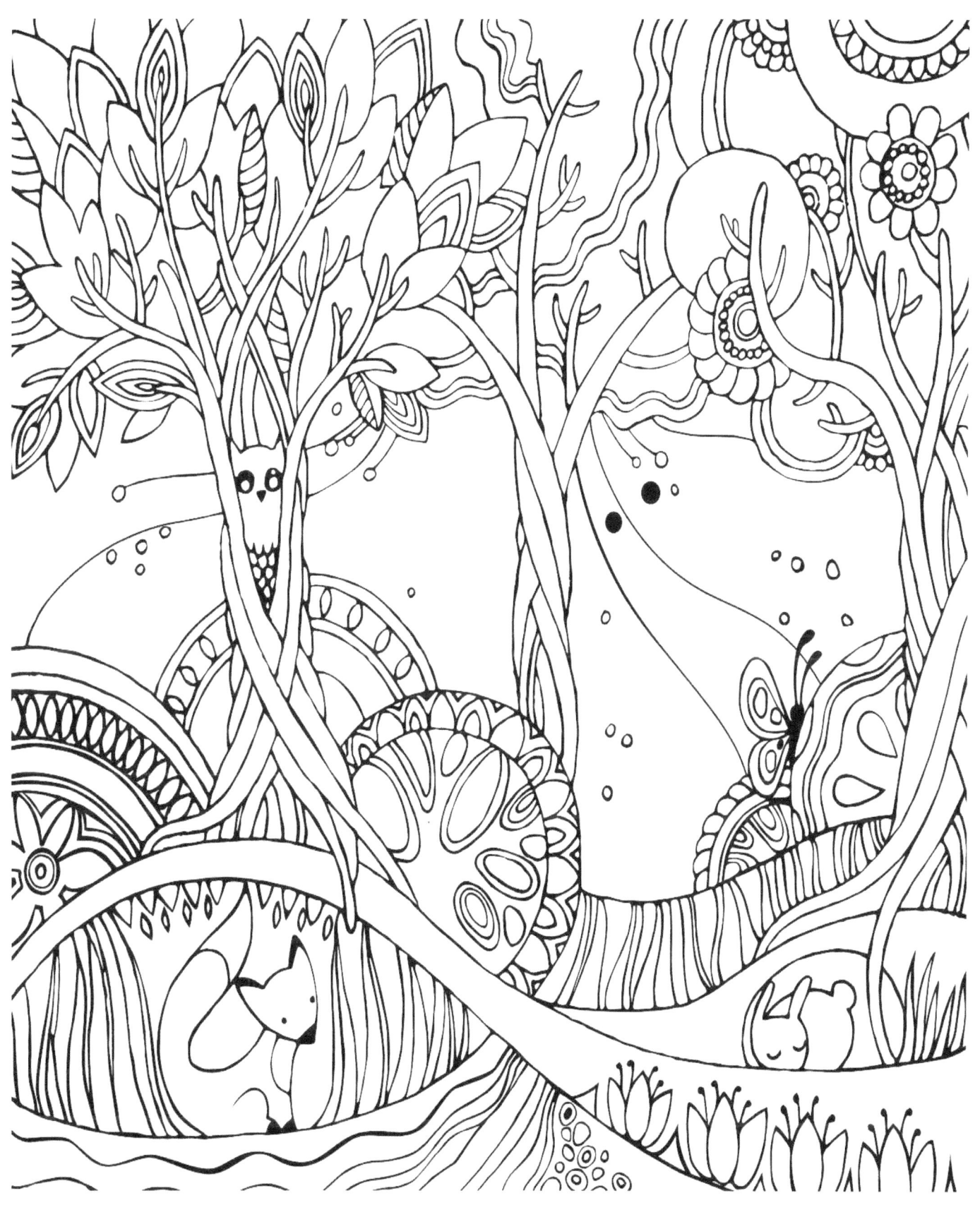

www.ingramcontent.com/pod-product-compliance
Lightning Source LLC
Chambersburg PA
CBHW080548190526
45169CB00007B/2680